To Nancy
With Sincere best
Wishes

Sterling Edwards

creating luminous watercolor landscapes

A FOUR-STEP PROCESS

Sterling Edwards

NORTH LIGHT BOOKS
CINCINNATI, OHIO
www.artistsnetwork.com

Other fine North Light Books are available from your favorite bookstore, art supply store or online suppler. Visit our website at www.fwmedia.com.

14 13 12 11 5 4 3 2

DISTRIBUTED IN CANADA BY FRASER DIRECT
100 Armstrong Avenue
Georgetown, ON, Canada L7G 5S4
Tel: (905) 877-4411

DISTRIBUTED IN THE U.K. AND EUROPE BY DAVID & CHARLES
Brunel House, Newton Abbot, Devon, TQ12 4PU, England
Tel: (+44) 1626 323200, Fax: (+44) 1626 323319
Email: postmaster@davidandcharles.co.uk

DISTRIBUTED IN AUSTRALIA BY CAPRICORN LINK
P.O. Box 704, S. Windsor NSW, 2756 Australia
Tel: (02) 4577-3555

Library of Congress Cataloging in Publication Data
Edwards, Sterling.
 Creating luminous watercolor landscapes / Sterling Edwards.
-- 1st ed.
 p. cm.
 Includes index.
 ISBN-13: 978-1-60061-469-9 (hardcover)
 1. Landscape painting--Technique. 2. Watercolor painting--Technique. I. Title.
 ND2240.E39 2010
 751.42'2436--dc22
 2010000231
Edited by Jennifer Lepore Brune
Production edited by Sarah Laichas
Designed by Guy Kelly
Production coordinated by Mark Griffin

About the Author

Sterling Edwards, greatly influenced by master painter Zoltan Szabo, has been studying watercolor for more than twenty years. He currently conducts classes for artists of all skill levels, and is a popular workshop and seminar teacher throughout the United States and Canada. His signature watercolor brushes and palette, along with a line of full-length instructional DVDs, are distributed internationally.

Sterling has been a featured artist in *Watercolor Artist* magazine, and he is a signature member of the Canadian Society of Painters in Water Colour. His paintings are in private and corporate collections worldwide, and in galleries in the U.S. and Canada.

Sterling works from his home studio in Hendersonville, North Carolina. Visit his website at www.sterlingedwards.com.

Dedication

I dedicate this book to my incredible wife Diane.

Metric Conversion Chart

To convert	to	multiply by
Inches	Centimeters	2.54
Centimeters	Inches	0.4
Feet	Centimeters	30.5
Centimeters	Feet	0.03
Yards	Meters	0.9
Meters	Yards	1.1

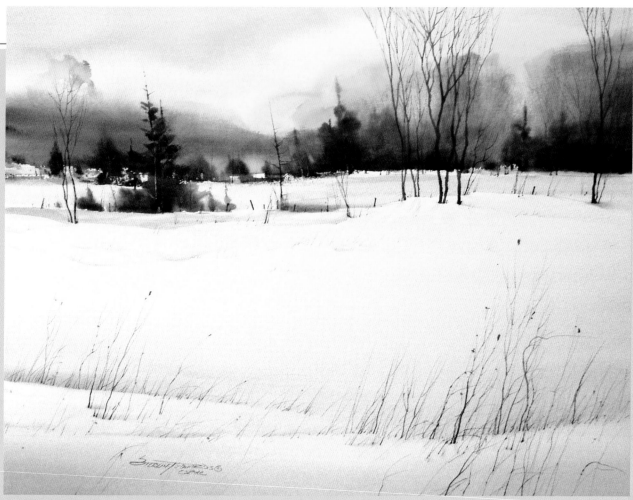

A Piedmont Snow Scene
Watercolor on 300-lb. (640gsm) cold-pressed Arches watercolor paper
22" × 30" (56cm × 76cm) • Private collection

Acknowledgments

There are so many people who have had an impact on my life and in some way brought me to this point. My parents, Fred and Patsy Edwards, have always been supportive and encouraging in my artistic endeavors, from the private art lessons in which they enrolled me when I was only twelve to the present. My two daughters, Lisa and Lauren, sacrificed many weekends to help me set up and manage my displays at numerous art shows early in my career. Spending weekends setting up at an art show is definitely not the ideal weekend for a young girl. Nevertheless, their willingness to help and their gracious attitudes were much appreciated. My wife, to whom I dedicate this book, has been a blessing in so many ways. Her belief that I would be successful even when I could not afford another tube of paint and her always-present "you can do it" words of encouragement have meant more to me than she will ever realize. The late Zoltan Szabo, whom I respectfully refer to as my mentor and friend, helped me to refine my talent. Through his guidance I learned to see the world through the eyes of an artist and create expressive works of art rather than merely copies. I consider myself very fortunate to have known such a fine man and artist. My editors, Jennifer Lepore and Sarah Laichas, have been great to work with. Their positive attitude and professionalism made writing a book doable. I also acknowledge all of my friends and students who have always been supportive and encouraging. There are too many to mention by name, but they know who they are. To all of them I extend a sincere thank you. Last but not least I would like to acknowledge my studio dog Jake, lovingly referred to as "Jake the Obtuse Dog." He kept me company for the last year as I spent many nights in the studio working on this book.

Table of Contents

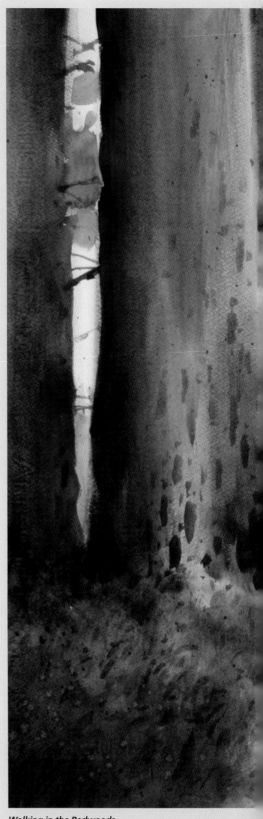

Walking in the Redwoods
Watercolor on 300-lb. (640gsm) cold-pressed Fabriano paper
22" × 30" (56cm × 76cm) • Collection of the artist

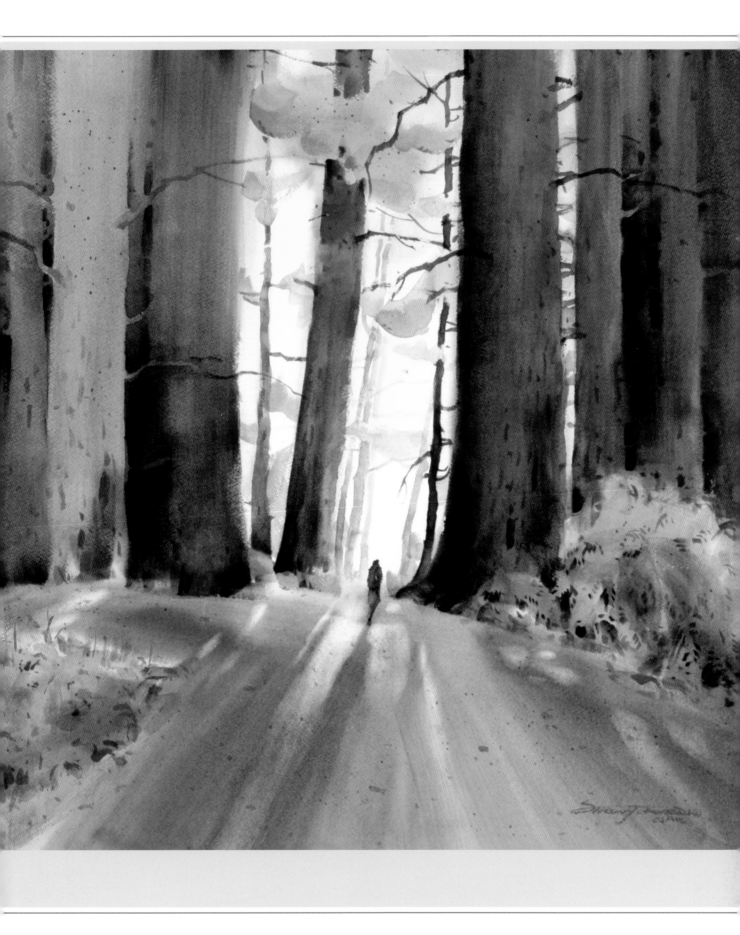

Introduction

I was strolling through an art exhibit years ago and stumbled upon an elderly gentleman doing a watercolor demonstration. I had always admired watercolor paintings and found them almost magical in the way colors melted together and ran in some areas while remaining bold statements in others. I watched as he wet the entire sheet of paper to the point where the water was literally dripping from the paper and off the edge of the table. I was particularly fascinated with the wet mixes of color that floated on his palette. He picked up one of his larger brushes and dipped it into a jar of water to saturate the brush and then dipped the brush in two of the colors. The suspense was killing me waiting for him to put brush to paper.

He put a small wood block under the paper to elevate the top. After a second or two, he quickly swiped the loaded brush across the top of the paper, resulting in an energetic explosion of running and fusing color. This was quickly followed with two more quick brushstrokes after which he turned to the spectators and stated that he usually did not work that hard on a sky. Lower jaws were hitting the floor as everyone stood mesmerized by the magnificent, loose-flowing sky that had just been rendered with only three brushstrokes.

At the time I was an oil painter and often spent a week or two painting a sky in one of my landscapes. I was a photorealist, and my measure of an exceptional artist could be weighed in how many hundreds of brushstrokes it took to paint a tree or some other element in a painting.

This isn't meant in any way to imply that photorealism is not good art because I know from experience that it takes years of observation and practice to master the process. There is a huge market and appreciation for photorealism and I was relatively successful. I guess my biggest concern was that I was not getting enough personal satisfaction from my paintings. Yes, they were pretty and yes, they were selling, but usually when I was about halfway through a painting, I became bored with the tedious and time-consuming process of painting each blade of grass in a forty-acre field or painting each leaf and branch in the forest.

I was a police officer and a firefighter at the time and worked swing shifts that limited my time to paint. Quite often when I did have the time, I didn't have the energy to sit down for hours with a two-hair brush and work on tiny shapes that seemed to never end. It was no wonder that on the day I watched an artist paint an entire sky with three brushstrokes I was enthralled with the thought of learning to paint with watercolors.

So began the quest. I enrolled in a weekly class at a local community college continuing education program. This was an eight-week course that I eventually took three times. I learned a great deal about this marvelous medium, but I was still caught in the grip of photorealism and could not put down the tiny brushes.

One day a friend asked me if I had seen the book by Zoltan Szabo. When I said that I was not familiar with his work, my friend was kind enough to loan me one of Szabo's books for a couple of weeks. The work was amazing with a clean presentation and beautiful, loose brushwork. A few months later I took a five-day workshop with Szabo in Asheville, North

In New Brunswick
Watercolor on 300-lb. (640gsm) cold-pressed Fabriano paper
15" × 22" (38cm × 56cm)

Carolina. He was a wonderful artist and a magnificent teacher. By the end of the week we had formed a friendship that lasted for sixteen years until his untimely death in 2003.

When I returned home from the workshop, I was determined more than ever to learn to paint with larger brushes and focus more on the larger shapes in the painting and less on the detail. It was a tough transition. Going from a two-hair brush to a two-inch brush was as awkward as learning to walk again. I made a lot of mistakes and went through the learning curve that any artist goes through when attempting a new medium. However, I was progressing and enjoying the time spent painting. I looked forward to every moment that I was able to paint. Sometimes that meant staying up late at night after my daughters had gone to bed.

Eventually I left law enforcement and opened a small art gallery in Winston-Salem, North Carolina. It was a beautiful gallery that came with a lot of bills to pay. To offset the expenses of running a gallery, I began teaching a Wednesday night watercolor class for beginners. I didn't consider myself an expert by any stretch of the imagination, but I had learned enough at that time to take someone with absolutely no experience and get them started as a watercolor artist.

When I was asked to teach a two-day watercolor workshop in a neighboring community, I was flattered and somewhat apprehensive. But being one who is not afraid of a good challenge, I accepted. Things went well and before long I was asked to conduct watercolor workshops for art guilds across North Carolina and Virginia. I was on my way even though I didn't quite know where I was heading except that I enjoyed teaching as much as I enjoyed painting.

One of the truly great things about being a traveling workshop teacher is meeting all the wonderful people along the way. Today I teach internationally and have made friends all across the U.S. and Canada. Through the

Near Brevard
Watercolor on 300-lb. (640gsm) cold-pressed Fabriano paper
15" × 22" (38cm × 56cm)

power of the Internet and DVDs I have met many more friends and loyal students in Europe and Asia as well.

Ten years ago if someone had suggested to me that I write a book, I would have been in a terrified state of disbelief. Today, however, it's another one of those big challenges that I find myself accepting as an adventure. This book is the culmination of years of learning, practicing, experimenting and always keeping an open mind about which direction my art is taking me. It's a road with lots of curves and very few rest stops. I will never learn it all, nor do I want to. Knowing there is so much more to learn keeps me thirsty for knowledge. My sincere hope is that this book will quench your thirst enough for you to be comfortable, but leave you thirsty enough to want more.

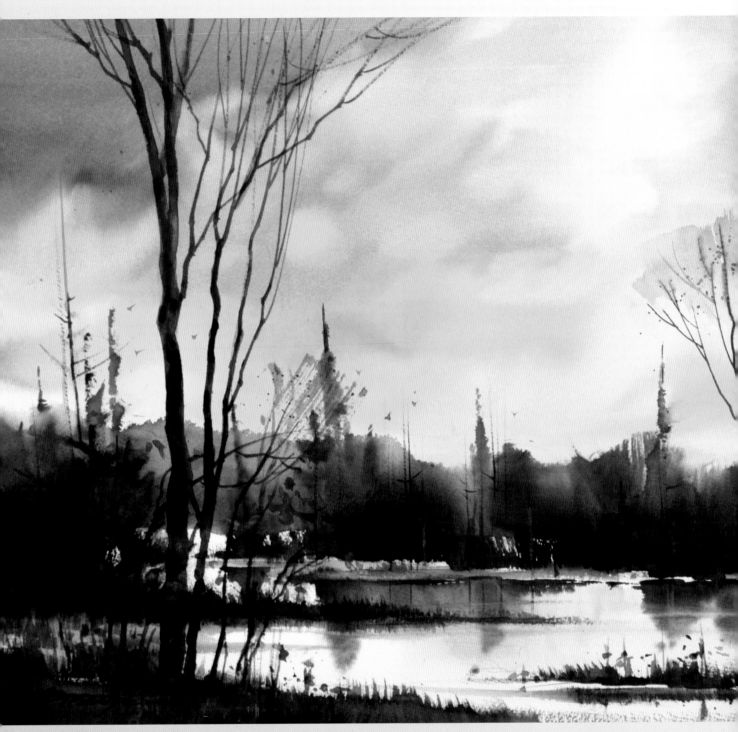

Last Glow
Watercolor on 300-lb. (640gsm) cold-pressed Fabriano paper
15" × 22" (38cm × 56cm) • Private collection

Tools & Materials

*I*t is such an exciting time to be a watercolor artist. There are thousands of supplies in most art supply stores, and new products are continually being introduced, offering a wide range of special effects designed to give your paintings a unique look. Though these products are fun to experiment with, they should not be a substitute for good watercolor technique. Learning to distinguish what materials you need for your style of painting will give you a definite advantage and make the learning process more enjoyable.

The materials in this chapter are what I find work best for me and the style in which I paint. Unless you are a beginning watercolor painter you probably already have some tools that have been tested and are tailored for your style of painting. If so, continue using them and maybe add to your collection of tools as necessary. The tools and materials I use are relatively inexpensive and good quality. I need to emphasize "good quality" because I have seen many students struggle with inferior quality tools and materials only to become frustrated and dissatisfied with the results. Good quality does not necessarily mean the most expensive.

So what are the right materials for you? This chapter will help you decide what you need if you want to use transparent watercolors to achieve luminous and fresh paintings.

Paints

Watercolor! What a fabulous medium. As an artist who has painted in almost every medium imaginable, I can truly say that I find watercolors the most intriguing and versatile of them all, no matter what your style.

In today's market there are numerous manufacturers of watercolor paint. Regardless of which brand you choose, use only professional-quality paint. Many of the student-quality brands do not behave as well as the professional-quality paint and can make the learning process more difficult when you eventually decide to use finer-quality paint.

Garret lake +

Permanent Yellow Lemon

Indian Yellow

Golden Lake

Orange Lake

Brown Stil de Grain

Avignon Orange

Permanent Red Deep

Primary Red-Magenta

Permanent Violet Blueish

Payne's Gray

Primary Blue-Cyan

Green Blue

Cupric Green Deep

Permanent Green Deep

My Favorite Paints

The paint that I use is MaimeriBlu, which is an Italian paint. I have tried many brands and find that MaimeriBlu professional-grade watercolor paint is reasonably priced and delivers excellent results every time. Furthermore, the paint stays soft and relatively moist on my palette even when allowed to dry in the color wells. It won't crack and crumble when dry.

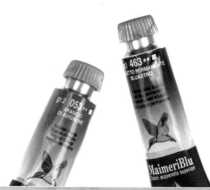

Watercolor Palette

Watercolor palettes come in a wide variety of styles and shapes. For most painters I would suggest a palette that has a cover to protect the paint in between painting sessions. Another feature that I like on a palette is ample room to mix and store colors.

Brown Stil de Grain (Warm)

Avignon Orange (Warm)

Permanent Red Deep (Warm)

Primary Red-Magenta (Warm)

Permanent Violet Blueish (Cool)

Payne's Grey (Cool)

Orange Lake (Warm)

Golden Lake (Warm)

Indian Yellow (Warm)

Permanent Yellow Lemon (Warm)

Primary Blue-Cyan (Cool)

Green Blue (Cool)

Cupric Green Deep (Cool)

Permanent Green Deep (Cool)

My Sterling Edwards Big Brush Palette

I use a palette that I designed: The Sterling Edwards Big Brush Palette. Since I paint primarily with large brushes, I designed this palette to accommodate a 2-inch (51mm) wide brush in each color well.

I like to arrange my colors so the warm colors are on the left and the cool colors are on the right. If I'm working on a painting that has predominantly warm colors, I will work from the left side of my palette, whereas if I'm working on a painting that has predominantly cool colors, I will work mostly from the right side.

It's OK to Let Your Paint Dry in the Palette

I squeeze an entire tube of paint into each well of my palette. If the paint dries, I just re-wet it with a damp sponge or mist water on the paint. Here are some advantages to letting your paint dry in the palette:

- You can tilt your palette when traveling without worrying about the paint spilling or oozing from the wells.

- You do not have to worry about contaminating the color when painting; just take a wet tissue and wipe the top of the paint off if it gets contaminated.

- It saves a lot of paint over time. When I used to squeeze fresh color with every painting, I had a tendency to dip my brush into the fresh paint and pick up too much paint. Ultimately I wiped the excess paint off on a rag or tissue wasting a lot of paint.

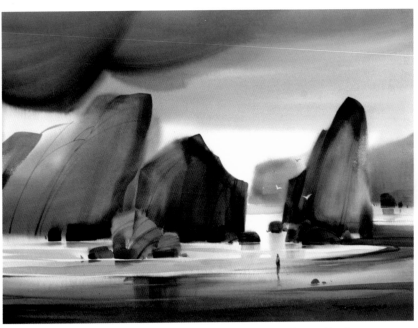

You Achieve Rich Colors With Dried Paint

This painting was completed at a workshop in Gold Beach, Oregon. Though the paint on my palette was totally dry prior to painting, a moist brush reactivated the paint allowing me to paint the rich colors in this piece. Notice the luminous transparency of the colors.

An Oregon Morning
Watercolor on 300-lb. (640gsm) cold-pressed Fabriano paper
22" × 30" (56cm × 76cm)
Private collection

Paint Characteristics: Transparency

It's important to know the degree of transparency of the paint you are using. When working in watercolor, there are basically three types of watercolor paint: transparent, semiopaque and opaque.

The paintings and illustrations in this book are all painted in transparent watercolor. But just to be sure that you have a good general knowledge of the three types of watercolor, let's discuss and illustrate the differences. I encourage you to try all three and see what works best for you. It's not unusual for many artists to use all three types of watercolor in the same painting.

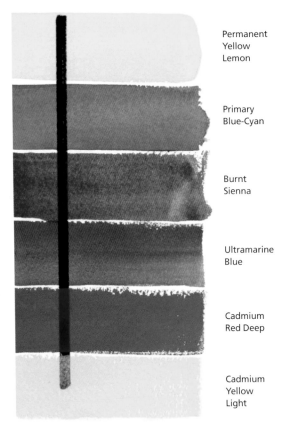

Permanent Yellow Lemon

Primary Blue-Cyan

Burnt Sienna

Ultramarine Blue

Cadmium Red Deep

Cadmium Yellow Light

Testing for Transparency

A good way to test the transparency of your watercolors is to draw a line on a piece of watercolor paper with a waterproof black marker. Paint a few brushstrokes of each of the colors you are testing across the line and allow them to dry. If the ink line is clearly visible through the paint as in the top two colors above, it is a transparent paint. The line is somewhat obscured in the third and fourth colors indicating they are semiopaque. The line is clearly diminished in the fifth and sixth colors indicating they are opaque colors.

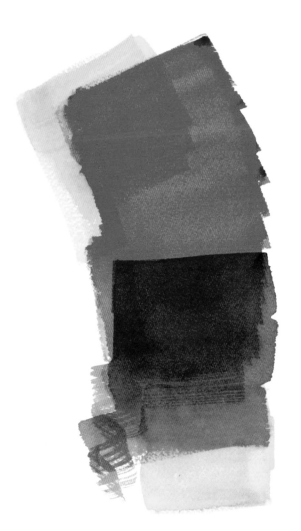

Transparent Watercolors

Painting with transparent watercolor allows light to pass through the paint so the white of the paper acts as a reflector. As the light strikes the white of the paper, it bounces back to the viewer, picking up the color of the paint. One of the main advantages of painting with transparent watercolor is that it allows you to layer colors to produce new colors. Each time you apply a color over another, it changes the hue because the previous color is now mixing with the current color.

In this example I painted a swatch of magenta and allowed it to dry, then added an overlapping swatch of blue to get a new color. Once this dried, I added yellow. Even though I have used only three colors, I now have red, orange, yellow, blue, violet and green. Because the three colors I used were all transparent watercolors, they maintain a distinctive luminosity from the white of the paper reflecting the light through the paint.

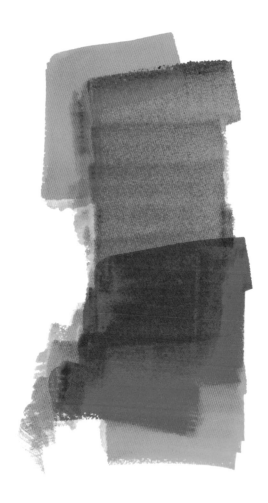

Semiopaque Watercolors

Semiopaque watercolors are similar to the transparent colors except they do not allow quite as much of the underpainting or white paper to show through the paint. Although it is possible to layer several colors, it will not appear as luminous and light as the same colors in a transparent paint. Sometimes the difference is negligible depending on the amount of water used in the paint. Less water and more paint will result in less transparency.

Here I painted swatches of semiopaque sienna, alizarin and orange (allowing each to dry first). The colors are semiopaque on their own, becoming more opaque as they are layered and less likely to create new colors.

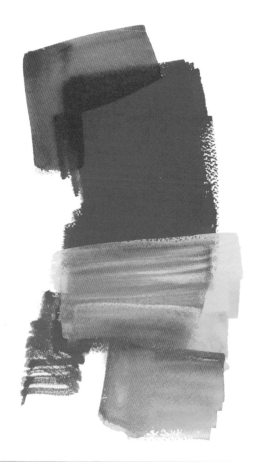

Opaque Watercolors

Depending on the amount of water used, opaque watercolor is more condensed and often contains white paint. This blocks the light from passing through the paint and striking the paper. Instead, the light reflects off the surface of the paint. I know some excellent artists who paint almost exclusively with opaque paint and achieve beautiful results. Their work, however, appears heavier and lacks the luminosity of paintings with transparent watercolor.

Here I painted swatches of opaque red, yellow and ochre (allowing each to dry first). These colors almost totally obscure the colors beneath them.

Paint Characteristics: Staining Powers

Staining colors actually stain the fibers of the watercolor paper. These colors cannot be lifted or scrubbed off of the paper easily because of the staining action. Most staining colors are manufactured from dyes rather than natural pigments. Nonstaining colors can be easily lifted with a damp brush and leave very little or no color residue in the fiber of the paper.

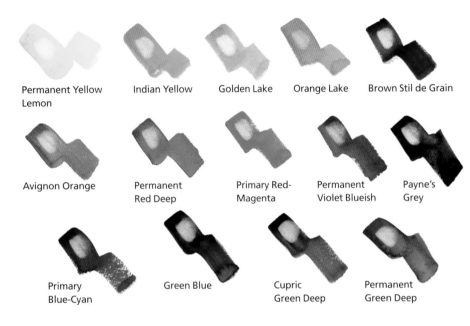

Permanent Yellow Lemon

Indian Yellow

Golden Lake

Orange Lake

Brown Stil de Grain

Avignon Orange

Permanent Red Deep

Primary Red-Magenta

Permanent Violet Blueish

Payne's Grey

Primary Blue-Cyan

Green Blue

Cupric Green Deep

Permanent Green Deep

Test for Staining
To test for lifting and staining ability, paint swatches of your favorite colors and let them dry. Then use a damp, soft watercolor brush and lightly scrub an area on each of the swatches. Once the color loosens, use a piece of tissue paper to blot off the lifted color. If the color is staining (such as Primary Blue-Cyan here), the color will remain in the paper fibers. If it is non-staining (such as Golden Lake here), the surface paint will lift off almost completely.

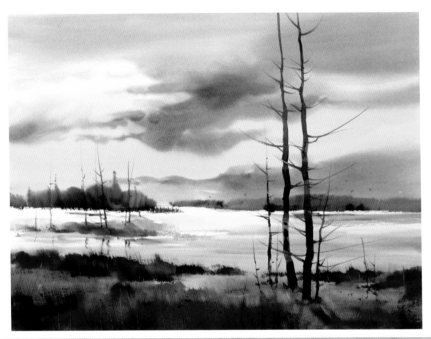

Choose Your Colors With Staining in Mind
In this painting of a marsh I found it necessary to lift some of the color in the foreground to suggest shadows from the trees. Rather than paint the shadows, I chose to lift color around the dark areas creating the illusion of shadows. The colors I used in the foreground are Golden Lake, Brown Stil de Grain and Permanent Violet Blueish. I knew from my lifting tests that these colors lift easily, so I felt confident using them in a painting where I anticipated lifting.

Paint Characteristics: Pigment Texture

Sedimentary colors are manufactured from natural pigments and have a grainy appearance when applied to watercolor paper. When the paper is wet, the heavy granules of ground pigment will deposit in the lower areas of the texture of the paper. The rougher the texture or *tooth* of the paper, the more graininess you will achieve.

Sedimentary Colors
This wash of Manganese Blue on a wet sheet of 140-lb. (300gsm) cold-pressed paper shows some graininess as the microscopic particles of pigment separate and settle in the tooth of the paper. The grainy texture of sedimentary colors can be a beautiful accent especially when painting loose and wet skies where atmospheric conditions need to be expressed.

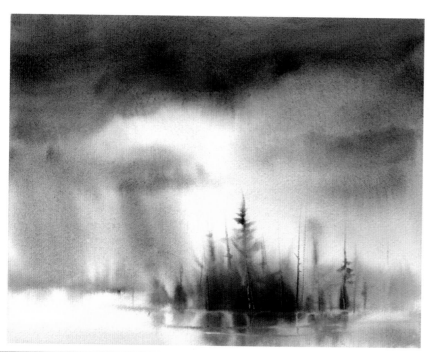

Painting With Sedimentary Colors
I painted the sky in this small study with a mix of Payne's Grey and Brown Stil de Grain on a piece of wet 300-lb. (640gsm) cold-pressed paper. I tilted the paper slightly to allow the colors to run down the wet paper. The graininess of the Payne's Grey is instrumental in helping to create the illusion of a foggy, rainy sky.

Brushes

If you have ever been in an art supply store or browsed through an art supply catalog, you have probably been overwhelmed with the variety of brushes available. They come in every size, color, shape and bristle imaginable.

I remember going into a tackle shop with my father years ago. There were walls and walls of lures in every size, configuration and color known to man. My father chuckled and said, "These weren't designed to catch fish; they were designed to catch fishermen."

The same is true with brushes. Like most artists I have tried a multitude of brushes always hoping to find that "magic" brush. I have concluded that it doesn't exist.

Bristle Type

Brush bristles can be synthetic, natural hair (such as sable) or a natural/synthetic blend. I have found that synthetic brushes work quite well. They are reasonably priced compared to the natural hair brushes that often cost much more. Synthetic brushes have a lot of spring, hold plenty of water and paint, and keep a good edge.

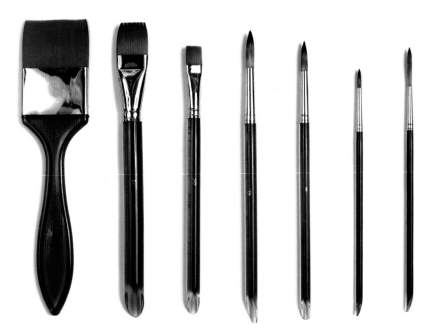

Soft Bristle Synthetics
These are the synthetic soft bristle watercolor brushes that I use. Top row from left to right; 2-inch (51mm) flat nylon, 1-inch (25mm) flat nylon, ½-inch (13mm) flat nylon, no. 12 round nylon, no. 8 round nylon, no. 4 round nylon and a no. 6 nylon rigger.

Stiff Bristle Brushes
Contrary to popular belief, stiff bristle brushes are ideal for watercolor painting. They are wonderful for applying heavy applications of paint and are good for softening edges. These are the Sterling Edwards Blending and Glazing stiff bristle brushes. An alternative is stiff bristle oil painting brushes.

Other Tips to Keep in Mind When Choosing a Brush

Choosing your brushes can be as personal as choosing your car, but these guidelines will help you make a more informed choice:

- The brush must feel comfortable in your hand.

- The bristles of the brush need to have plenty of spring in them so that when the brush is wet, it returns to its original shape when lifted from the paper.

- Flats, rounds or riggers? The shape of the brush will be useful for different subjects, so choose accordingly.

- When choosing a flat brush, make sure it has a sharp edge when wet. This is essential for painting shapes with hard and straight edges.

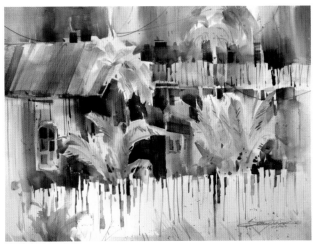

Painting With Flat Brushes

This painting of an abandoned building in Costa Rica was painted almost exclusively with flat brushes. Because most of the shapes were introduced with flat brushes, the painting has an angular appearance including the trees. A rigger brush was used to suggest some of the finer lines toward the end of the painting.

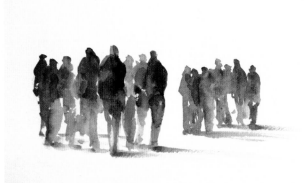

Painting With Round Brushes

Round brushes are excellent when you wish to paint subjects that have curves such as people, flowers and clouds. They are also very useful for painting fine lines such as trees, grass, boards on buildings and other subjects where a fine or direct line is necessary.

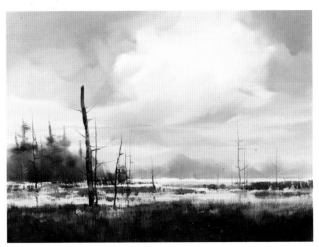

Painting With Bristle Brushes

The edges of the clouds in this painting were softened using a slightly damp bristle brush while the shapes were still wet. The background and middle ground trees were all painted with a bristle brush using drier loads of paint on the wet paper. The grassy shapes and textures were all created using the bristle brush.

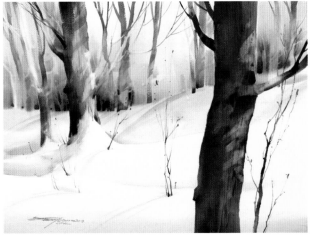

Painting With a Variety of Brushes

The large washes of color in the foreground and background of this painting were done with a 2-inch (51mm) flat soft brush. The trunks of the background trees were painted with 1-inch (25mm) and ½-inch (13mm) flat soft brushes. The large foreground tree was painted mostly with a 2-inch (51mm) flat soft brush. The larger tree branches on the foreground and background trees were painted with a no. 8 round brush. The smaller branches and blades of grass were painted with a no. 6 rigger brush. The leaves were painted with a no. 8 round brush. Note the areas on the large foreground tree where some paint was lifted to create the look of sunlight hitting the tree.

Paper

A good quality watercolor paper is necessary for professional results. There are many good brands of paper available in most art supply stores.

Paper Texture

There are essentially three types of watercolor paper: rough, cold-pressed and hot-pressed. Cold-pressed and rough papers absorb more color and have a surface texture (tooth) that is ideal for special effects such as dry brush. Hot-pressed paper has a smoother surface and does not absorb as much paint into the paper. Since the paint dries more on the surface of the paper, there is a tendency for the wet paint to dry in small pools of color. All of the paintings in this book are painted on cold-pressed paper.

Paper Thickness

Watercolor paper also comes in varying degrees of thickness, commonly referred to in pounds—the smaller the number of pounds, the lighter weight the paper. The difference in weight can affect the outcome of the painting. I have found that I get the best results on either a 140-lb. (300gsm) or a 300-lb. (640gsm) cold-pressed paper. The latter has a tendency to absorb more of the color, thus giving the finished painting a softer look.

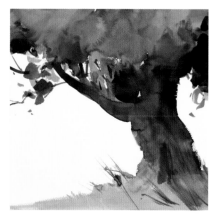

Cold-Pressed Paper
Cold-pressed watercolor paper allows for some scrubby texture, but is smooth enough to paint exact lines and achieve soft, blended edges.

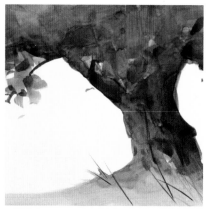

Hot-Pressed Paper
The paint on hot-pressed paper has a tendency to rest and dry on the surface of the paper, which makes it difficult to add more colors without disturbing the existing colors. It also allows individual brushstrokes to be seen.

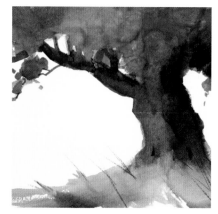

Rough Paper
Typically I only use rough paper when I'm painting a subject that is highly textured such as woods, old buildings and moving water. The rough texture of the paper makes it a little harder to paint fine line detail.

Stretching Paper

To keep your paper from *buckling* (warping and curving) as you paint, you'll want to stretch it before painting. Just saturate the sheet completely with water, then secure the paper to a Masonite, plywood, foamcore or Plexiglas mounting board using staples, clips or masking tape. Once the paper has been stretched and secured, it is ready to paint. The finished painting will dry flat, which makes framing the painting easier and more attractive.

Other Tools

In addition to the paint and brushes, other tools are sometimes necessary to paint a watercolor painting.

Toilet Tissue Blotter

A blotter is probably one of the most important tools you will use other than your brushes. It will help you control the amount of water in your brush so you don't get blossoms of color or *back runs* when painting on an area of paper already wet with paint. By merely tapping the brush on the blotter you can remove any excess water in the brush. To make a toilet tissue/paper towel blotter take a four- to five-foot-long paper towel, fold it in half lengthwise and roll it around toilet tissue.

Water Containers

Keep two containers of water on your painting table. Use one to rinse your brushes and the other for clean water to apply to your painting. Preferably the containers should be only a few inches deep so you can bang the brushes on the bottom of the container to dislodge any paint that has built up in the brush.

Masking Tape

Masking tape works well for taping heavier sheets of paper to a mounting board. It is inexpensive and available in most hardware and grocery stores.

Facial Tissue

I keep these on hand to wipe the tip of the brush and remove any unwanted water or paint or to wipe water or paint from my painting. Just make sure the kind you use does not contain any lotion or oil.

Large Clips

Large, spring-activated clips are useful for securing your watercolor paper to a mounting board.

Kneaded Eraser

A kneaded eraser is simply a soft, pliable eraser used to remove pencil marks from the watercolor paper either before or after the painting is completed. The eraser can be molded to a point to erase small areas or flattened to erase large areas. Since the eraser is soft, it will not damage the paper.

Pencil

I use a 2B pencil when doing the preliminary drawing on my watercolor paper. It has a very soft lead and erases relatively easily depending on how heavy you make the drawing. For the best results, make the sketch very light and draw as little as possible.

Scraping Tools

You'll want to keep a knife, an old credit card and a razor blade on hand to create textures as you paint.

Masking Fluid

Masking fluid is sometimes used to protect an area from receiving paint. It can be applied with a brush into any shape and when dry, painted over. The masked area will be protected from the paint. When the painting is dry, the masking peels off the paper, revealing an unpainted area.

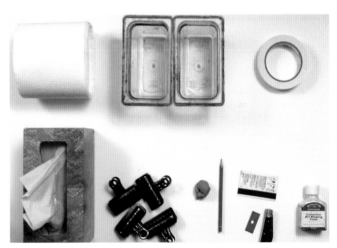

Basic Tools for Watercolorists
Clockwise from left to right: Toilet tissue blotter, water containers, 1-inch (25mm) masking tape, masking fluid, old credit card, knife, single-edged razor blade, 2B pencil, kneaded eraser, large clips and facial tissue.

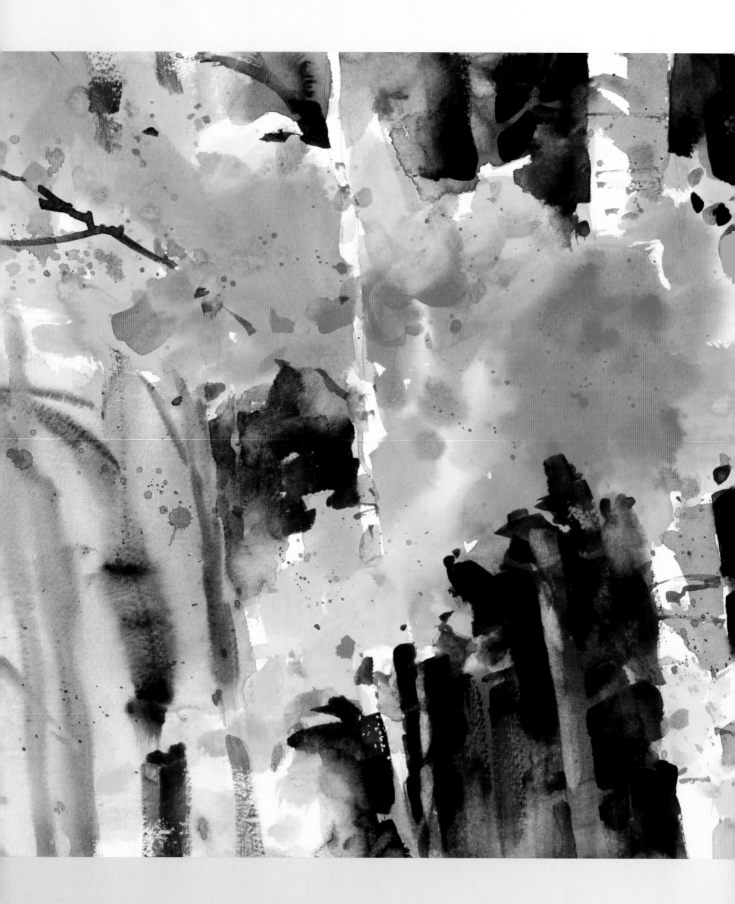

Color

*I*t wouldn't be a book on watercolor painting without discussing color. It's a diverse subject full of possibilities and surprises. To help you become familiar with colors, I'd like to simplify color theory somewhat by showing what I have found works well for me.

Autumn Expressions
Watercolor on 140-lb. (300gsm) cold-pressed Fabriano paper
11" × 15" (28cm × 38cm)

Primary and Secondary Colors

Understanding the basics of color will help you create luminous mixtures for your transparent paintings. The primary colors for mixing all other colors are red, blue and yellow. Mixing pairs of primaries results in the secondary colors: orange, purple and green. Mixing secondaries and primaries yields unlimited mixtures, called tertiary colors.

The Primary Colors

Red, yellow and blue are called the primary colors because every other color derives from them. It is impossible to create any of the primary colors by mixing two or more colors together. When two primary colors are mixed in equal parts, one of three secondary colors is produced: orange, purple or green.

red orange yellow

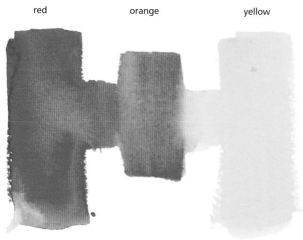

red purple blue

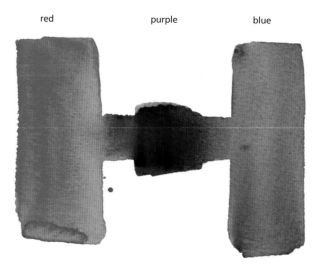

blue green yellow

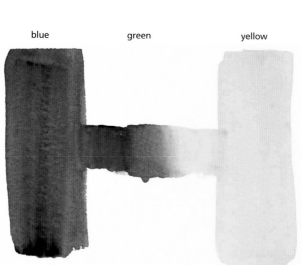

Creating Secondary Colors

If you mix equal parts of two primaries, you achieve a secondary color. If you mix unequal parts of each color, you achieve a secondary color with a primary dominance. Orange can range from a bold, dark red-orange to a light, soft yellow-orange. Greens can be dark and cool by mixing more blue, or they can be warm and springlike by mixing more yellow. Purples range from reddish purple to bluish purple, depending on the mixture's ratio of red to blue.

Create a Color Wheel Using the Colors of Your Palette

Studying the color wheel can help you avoid dull and muddy colors by learning which hues mix naturally together. Mud is one of the most common problems that artists experience mixing color. It is the dull and lifeless color that results from mixing and overworking complementary colors. Complementary colors are those directly opposite each other on the color wheel—red and green, blue and orange, and yellow and purple. We will discuss complementaries later in the chapter.

A color wheel is a wonderful tool to help you understand color theory. You can either purchase a color wheel from your local art store or make your own using the colors on your palette. Keep in mind the names of paints may vary by manufacturer. In this exercise I use MaimeriBlu transparent watercolors.

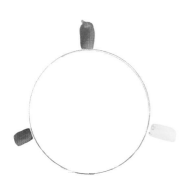

1 Draw a simple circle on paper and place the three primary colors at one-third increments around the wheel. Here I used Permanent Red Deep, Permanent Yellow Lemon and Primary Blue-Cyan.

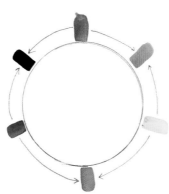

2 Begin with red and yellow and move clockwise around the wheel, mixing the three secondary colors. Mix an equal amount of red with yellow, then place a swatch of orange on the wheel between the two colors. Repeat with yellow and blue, and blue and red.

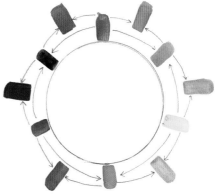

3 Continue moving clockwise around the wheel to create a new generation of colors. Red-orange, yellow-orange, yellow-green, green-blue, blue-purple and red-purple.

4 More and more generations of color are possible by merely mixing two adjacent colors and placing the new mixture in the space between. Allow the color dominance to be altered as you move clockwise. Take the time to study the various color combinations created with the colors you have on hand. It will be time well spent.

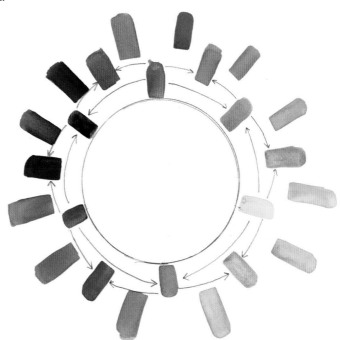

Complementary Colors

I've found that the most important aspect of the color wheel is simply learning that any color directly opposite another color on the color wheel is its complement. Another is that when complements are mixed in equal parts on wet paper you create a neutral gray color. Neutrals are attractive in a watercolor painting provided they stay relatively clean and transparent.

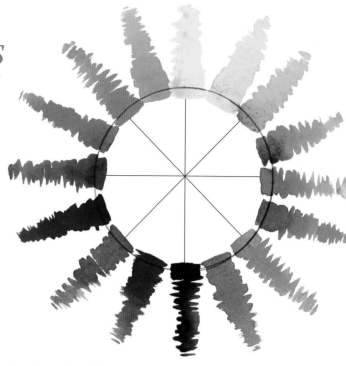

Complementary Colors
Complementary colors are directly opposite each other on the color wheel. When used in the same painting, they can neutralize each other and become gray. If overworked with other colors, they can quickly become muddy.

Soft Ground
Watercolor on 300-lb. (640gsm) cold-pressed Arches paper
15" × 22" (38cm × 56cm)

Mix Two Complementary Colors to Create Gray
This simple painting is comprised of two complementary colors: Golden Lake and Permanent Violet Blueish, essentially a yellow and a violet. When two complementary colors neutralize each other, they become gray. Mixing gray with a pure color will soften it.

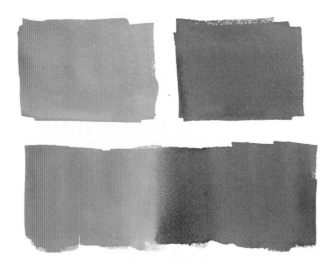

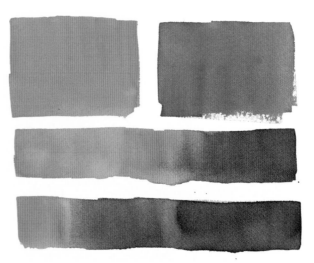

Mixing Complements Creates Neutral Grays
This example shows how equal parts of Orange Lake and Primary Blue-Cyan become neutralized into a gray when mixed together. This mixture is very neutral but still has some transparency. Mixing complementary colors produces a wide variety of grays that have more visual excitement than using grays that are premixed in a tube.

Use Color Dominance to Determine What Kind of Gray You Create
If you mix more of one color, the neutral will have a dominance of that color. The middle bar shows a neutral with an orange dominance, whereas the bottom bar shows the same colors mixed together but with a blue dominance.

How to Avoid Mud

As you push other colors into the neutral, they will often have a tendency to get a dull and sometimes opaque quality that is commonly referred to as mud. Mud is the result of poor color selection and overworking, eliminating the luminous, transparent quality of watercolors.

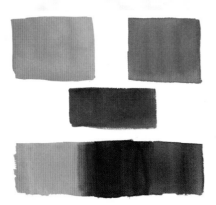

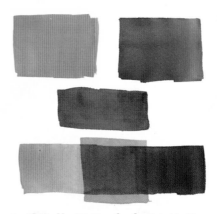

Mixing Colors While Wet May Cause Mud
When green is introduced into this wet mix and worked into the neutral, a flat and opaque mud begins to show its ugly face. The more you work this area on wet paper, the muddier it will get.

Avoid Mud by Waiting for the Paint to Dry
Wait until your neutral mix has dried before laying on the green, and watch as the green maintains its transparency and creates another beautiful gray. Be careful—the wet color you are applying will moisten the existing color, causing it to mix with the newer color and produce mud.

Other Useful Color Schemes

The color wheel is a great tool for learning what colors go well together. We've seen what complementary colors do, so now let's look at a few other common color combinations that work well.

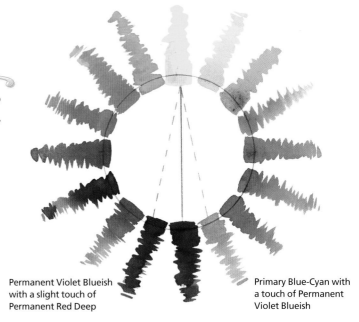

Permanent Yellow Lemon

Permanent Violet Blueish with a slight touch of Permanent Red Deep

Primary Blue-Cyan with a touch of Permanent Violet Blueish

Split Complementary Colors
The colors on either side of a complementary color are called *split complementary colors*. As with complementary colors, they create a beautiful color harmony with their complement, but can get muddy if additional colors are added and overworked.

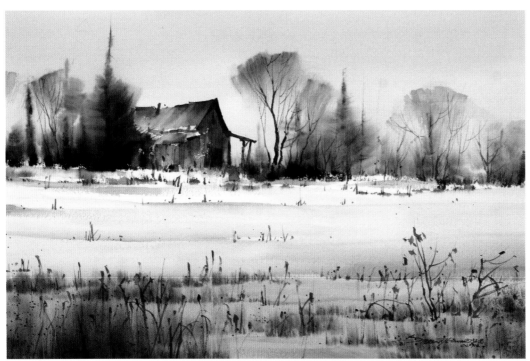

Split Complementaries in Action
Split complementary colors are located beside a complementary color on the color wheel. A split complementary color scheme creates a diverse and harmonious bond between the colors because they are in the general range of natural complements. In this painting, Primary Blue-Cyan is complemented by two combinations: Orange Lake and Primary Red-Magenta, and Orange Lake and Indian Yellow. I achieved a balance of warm and cool colors that appear softer than if I'd only used regular complementary colors.

Behind the House
Watercolor on 300-lb. (640gsm) cold-pressed Fabriano Artistico paper
15" × 22" (38cm × 56cm)

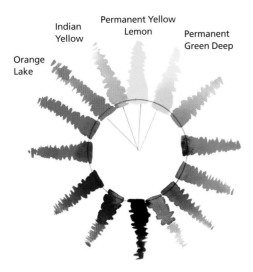

Indian Yellow · Permanent Yellow Lemon · Permanent Green Deep · Orange Lake

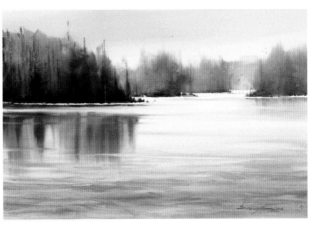

Analogous Colors

Three or four colors that are adjacent on the color wheel are called *analogous colors*. Paintings with an analogous color scheme exhibit a cohesive quality where the colors are similar in hue but different enough to maintain their originality. Unless the painting is severely overworked, there is little chance of getting muddy colors in an analogous color scheme because there is not a prominent complementary color.

Analogous Colors in Action

Painting with an analogous color scheme decreases the likelihood of producing mud because complementary colors are not used. The analogous colors used in this painting are Primary Blue-Cyan, Green Blue and Permanent Violet Blueish. All of the colors in this painting are on the cool side, which fits the subject nicely. But because I didn't use any complementary colors of blue and violet—yellow or orange—the painting is mud free.

Calming
Watercolor on 300-lb. (640gsm) cold-pressed Fabriano Artistico paper
15" × 22" (38cm × 56cm)

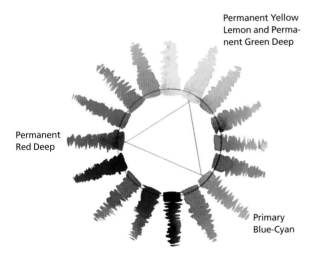

Permanent Yellow Lemon and Permanent Green Deep · Permanent Red Deep · Primary Blue-Cyan

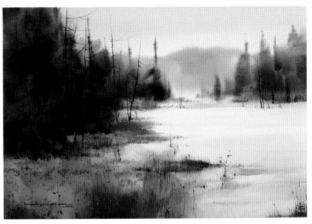

Triadic Colors

Triadic colors are any colors spaced at an equal and triangular distance from each other on the color wheel. Paintings that exhibit a triadic color scheme display a well-balanced use of warm and cool colors. Regardless of what colors you choose, the combination will offer a wide variety of hues when mixed in various combinations.

Triadic Colors in Action

A benefit of painting with a triadic color scheme is the variety of neutrals and grays that are possible. The triadic colors in this painting are Permanent Green Deep, Permanent Violet Blueish and Orange Lake. A mixture of Permanent Violet Blueish and Orange Lake warms the cold snow scene by creating a warm neutral that dominates throughout the painting.

Easy Walking
Watercolor on 300-lb. (640gsm) cold-pressed Arches paper
15" × 22" (38cm × 56cm)

Establishing Mood With Color

A painting can be interpreted any number of ways depending on the style and what the individual viewer perceives. Taking a little artistic license with color, however, often sets the mood for the painting and helps to convey your intentions to the viewer.

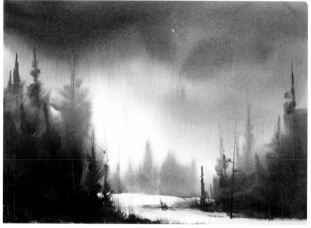

Somber
The gray sky in this painting conveys that there is not a direct light source. Therefore, the colors are somewhat muted and somber. It's very quiet and there's a feeling of solitude. Notice how the gray in the sky is echoed in the shadow colors. Paintings with gray skies can be quite beautiful but before you paint one, determine if this is the feeling you want to convey about the scene.

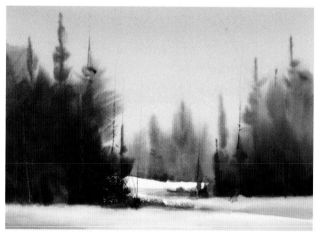

Happy
The same scene with a blue sky suggests that the sun is shining because there are not any clouds to block the light. Even though the sky suggests a sunny day, the scene looks cold and crisp. Notice how the blue of the sky is echoed in the shadows.

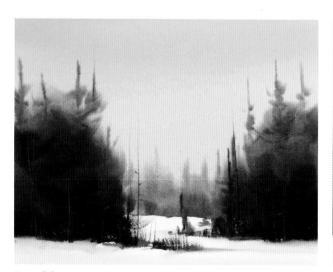

Peaceful
The same scene painted with a warm sky suggests a sunset or sunrise. Notice how warm the scene appears because of the warmer colors in the sky. The same warm colors are also echoed in the snow. This scene looks inviting and peaceful.

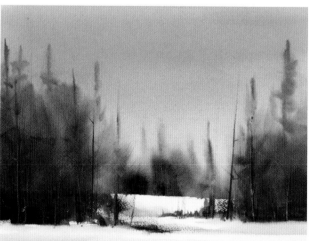

Calm
The colors in this example create a sense of calm and comfort. The complementary use of violet and yellow evokes a relaxed and warm feeling even though it is a winter scene. Notice how the yellow trees seem to dominate this painting. The purple sky commands attention, but the bold shapes of the trees are what creates the mood.

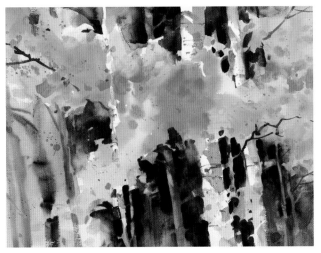

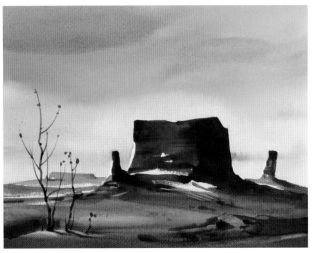

Bright Colors and White Paper Convey Excitement

The riotous colors of autumn scenes give paintings a sense of excitement. Since most of the colors that you see in an autumn scene are relatively close on the color wheel, there is little chance of getting dull or muddy colors. On these tree trunks, the white paper sets the stage for the beautiful gray on the trunks and makes the leaves look brighter.

Use Colors That Feel Like Your Subject

Even if there were no buttes or mesas in this painting, the colors alone might suggest that you are in the Southwest. Having fun with color rather than always trying to replicate local colors opens a whole new world of possibilities and will do wonders to make your paintings more expressive.

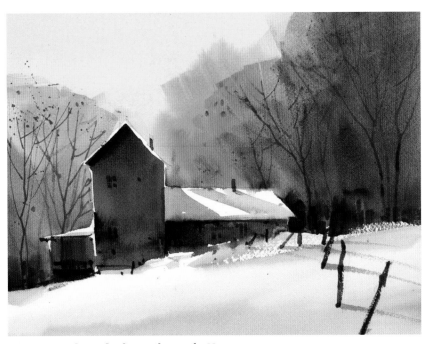

Exaggerate Color and Value to Change the Norm

The exaggerated colors and values in this small study set the stage for a combination of warm and cool. The warm oranges and yellows in the sky and trees are the largest and brightest shapes, therefore dominating the scene. It's obviously a snow scene, but the cold of the snow has been minimized by the expressive use of the warm colors. The colors and rich values in this painting not only command attention but create a mood as well.

Keep Your Colors Strong

Always remember that as you are applying additional layers of color to your painting, you are also re-wetting the existing colors. If you apply too much brush action, the colors all mix to become one color and you will have lost an opportunity to have more color excitement. Overexaggerate the color with the first application to minimize the risk of having to go back and add more color later.

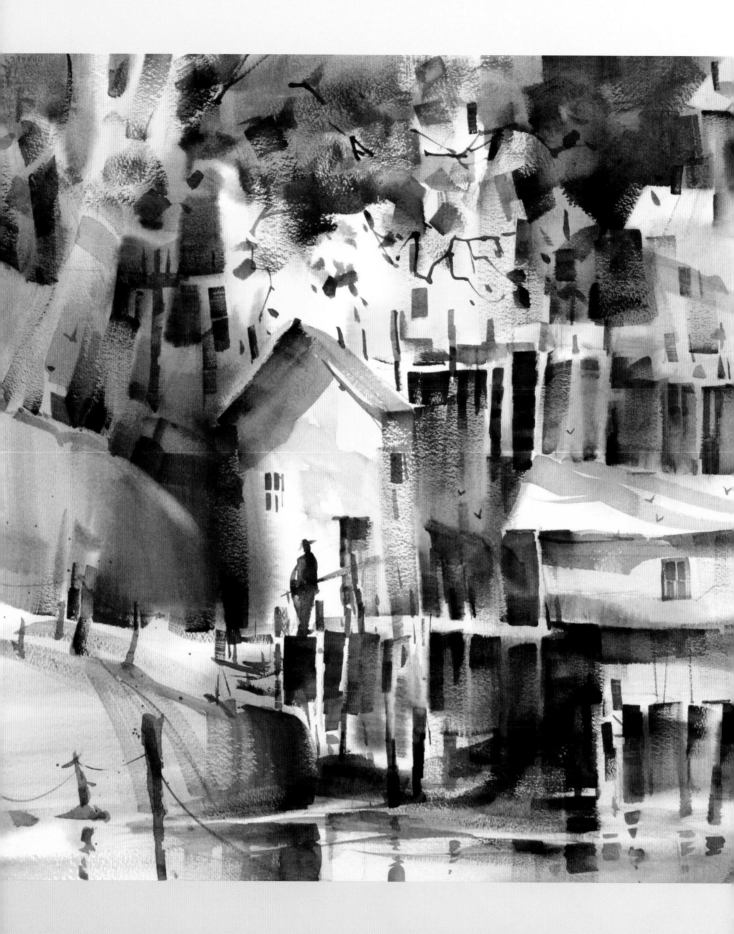

Techniques

*I*n the next several pages we're going to discuss and illustrate some of the most common watercolor techniques that will make your paintings more interesting and entertaining. I really do need to emphasize "entertaining." A chef entertains the taste buds, a musician the ears. The visual artist's job is to entertain the eyes and the imagination. Having a tool chest full of exciting ways to manipulate a brush or add a special texture to your painting will offer a variety of ways to make your paintings more entertaining and successful.

Empty Handed
Watercolor on 300-lb. (640gsm) cold-pressed Fabriano paper
22" × 30" (56cm × 76cm) • Private collection

Four Ways to Apply Paint

Throughout this book you will see numerous examples of watercolor paintings that show a multitude of watercolor techniques and subject matter. Even though there are distinct differences from one to the next, they are all painted using various combinations of four basic applications of watercolor. Learning when and how to apply the paint in the correct manner will enable you to gain the experience and confidence to tackle most subjects.

Wet-On-Dry Painting
Wet-on-dry painting refers to wet paint applied to dry paper. Since the paper is dry, the paint will not run, giving you total control over individual shapes. Anytime a shape needs to have sharp edges, it should be painted on dry paper.

Dry-On-Wet Painting
Dry-on-wet refers to applying paint that is semi-wet to wet paper. A good example of semiwet paint would be paint that has about the same consistency as melted butter. When this thicker paint touches the wet paper, it will soften around the edges but will still maintain some of its shape.

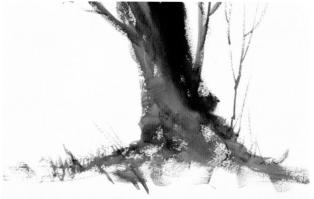

Dry-On-Dry Painting
Dry-on-dry refers to painting with dry paint on dry paper. Another commonly used name for this technique is *drybrush*. One of the most effective ways to achieve a dry-brush look is to hold the brush almost parallel with the paper and make a quick brushstroke. The paint in the brush will lightly be deposited on the higher areas of paper and avoid settling in the valleys. The result is a broken, textured brushstroke. Drybrush is very effective when you are trying to suggest old wood, leaves on trees, tree bark, etc.

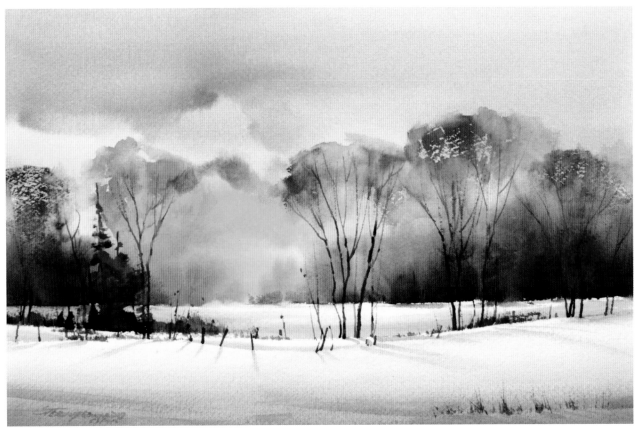

Create Luminous Skies, Wet-On-Wet

When painting a sky in a landscape, it would make the painting more inter-
esting to have two or three wet colors mixed with water and ready to apply
so they will all run and interact with each other.

A Davidson County Sunset
Watercolor on 300-lb. (640gsm) cold-pressed Fabriano Artistico paper
15" × 22" (38cm × 56cm) • Private collection

Wet-On-Wet Painting

In this type of application you are painting wet paint onto wet paper. When I
refer to wet paint, I am talking about a very watery mix that closely resembles
water with food coloring. Allowing colors to mix on wet paper produces
some beautiful secondary colors that would be difficult to mix with a brush.

Watch Color Mingle With Water

Completely wet a piece of 140-lb. (300gsm)
cold-pressed watercolor paper. Starting at the top
of the paper, lay a wash of wet magenta paint (I
used Primary Red-Magenta) and slightly tilt the
paper. The wet paint mixes with the water on the
paper and begins to run.

Add a Second Color

Drop in a wet yellow (I used Golden Lake) here
and there, being careful not to brush all of the
colors together into one color.

Add a Third Color

Now drop in a wet blue (I used Permanent Violet
Blueish). It's fun to tilt the paper a little and see
how the colors run together as they gravitate
toward the bottom of the paper.

Scraping

Scraping is always an effective way to add an unusual accent or texture to a watercolor painting. Anytime you scrape, you are abrading and scarring the surface of the paper. The key to making the scraping work properly is pretty much a matter of timing.

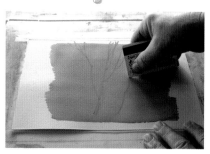

Create Dark Accents
To suggest the detail of tree branches, boards or blades of grass, use a brush handle, credit card, knife or razor blade, and your fingernails to scrape a wet shape while the surface is still shiny. Hold the tool at an angle to the surface to avoid surface damage. The created depression on the surface will collect water and pigment, leaving a dark line or accent against a lighter background.

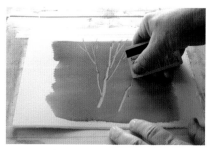

Create Light Accents
To achieve a light shape or line on wet paper, wait until the surface shine is gone before scraping. This technique requires delicate timing—if you wait too long, the paper will dry to the extent that you cannot push the paint aside.

Texture Techniques

I never cease to be amazed at all the ways we can add texture to a watercolor painting. Just when I think I've heard them all, a student at a workshop will show me something they stumbled upon or learned at another workshop. This is why I have referred to myself as a lifelong student of watercolor. We can never learn it all, nor should we want to. Constantly learning new tricks and new ways of using this wonderful medium to express ourselves is far more rewarding than knowing exactly what to do and then just doing more of it.

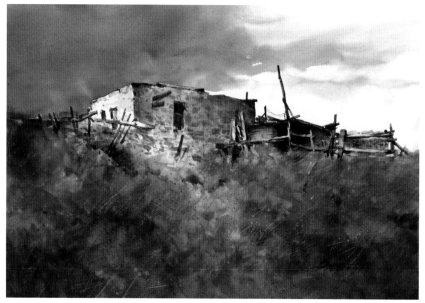

Grassy Texture
I scraped out grasses in the foreground of this painting, just as the wet paint started to lose its shine.

On the Road to Acoma
Watercolor on 300-lb. (640gsm) cold-pressed Fabriano Artistico paper
15" × 22" (38cm × 56cm) • Private collection

Splattering

Splattering is one of the accents and textures that I love the most because it helps give a painting a loose and spontaneous appearance. It's easy and fun as long as it's not overdone or too messy.

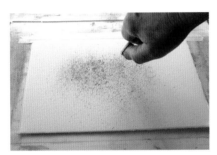

Wet Color on Dry Paper

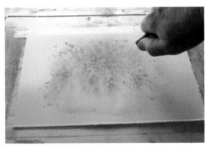

Wet Color on Wet Paper

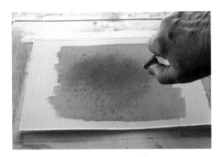

Wet Color on Dried, Painted Surface

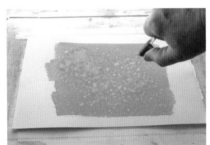

Water Splattered on Wet Color

Four Ways to Splatter

There are many ways to splatter paint, but it's important to maintain control of the splatter—an old toothbrush works well to create interesting texture in your painting.

Hold the toothbrush over the paper with the bristles pointed toward the paper and rake your thumb over the bristles. Shake the toothbrush before doing this to make sure there is not an abundance of water in the toothbrush. It's also a good idea to use a scrap piece of paper to cover the sky or any area of your painting you don't want to get splattered. I often use the splatter technique at the end of my painting as a final textural element.

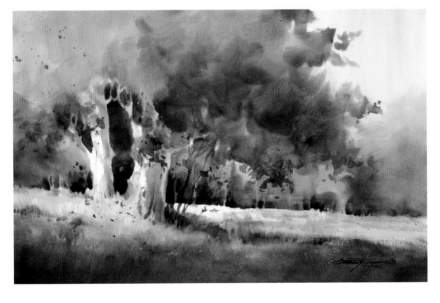

Exciting Accents

Controlled splattering creates exciting, crisp accents reminiscent of leaves against the soft shapes of the trees and grassy areas.

This is also a great way to show snow falling in a winter scene (use white opaque paint) or to portray sand or pebbles.

Other Fun Texture Techniques

Scumbling, salt, rubbing alcohol and plastic wrap are quick and easy ways to add instant texture to your painting. But as with any special texture or technique, a little goes a long way. Too much and your painting can look gimmicky.

1 Paint the Colorful Shapes of the Foliage
Using a 1-inch (25mm) flat, paint the shape of a tree with Permanent Yellow Lemon, Indian Yellow and Orange Lake.

2 Spray Rubbing Alcohol Onto the Wet Shapes, Then Add the Trunk and Branches
When the paint has lost its shine and is semidry, use a spray bottle to apply the rubbing alcohol to the shapes. The alcohol creates an immediate texture resembling individual leaves. When the tree is dry, paint the trunk and smaller branches with a combination of Orange Lake, Permanent Violet Blueish and Primary Blue-Cyan.

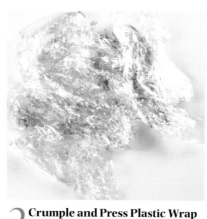

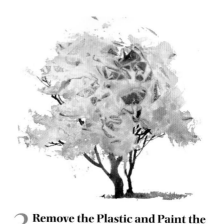

1 Paint the Foliage
Apply wet washes of Indian Yellow (top), Permanent Green Deep (middle) and Primary Blue-Cyan (bottom) using a 1-inch (25mm) flat. Allow the wet colors to mix naturally on the paper.

2 Crumple and Press Plastic Wrap on the Wet Shapes
While the foliage shapes are wet, place a piece of crumpled plastic wrap on the paper and allow it to dry naturally.

3 Remove the Plastic and Paint the Trunk and Branches
When the paint has dried thoroughly, remove the plastic wrap and paint the trunk and branches of the tree using a dark combination of Orange Lake, Permanent Violet Blueish and Primary Blue-Cyan.

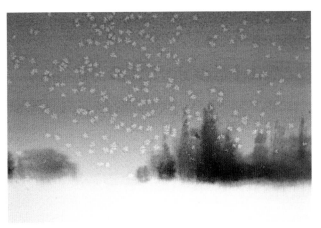

Scumble Color

Scumbling is an effective brush technique for adding broken, scrublike textures to your painting that might suggest grass, leaves, old wood, etc. It is very similar to drybrushing in the way the brush is held, but unlike drybrushing because you can often use wet paint rather than dry paint. The rougher the surface of the paper, the better this technique will work since the paint is mostly deposited on the peaks of the paper's surface.

Add Salt to Wet Paint

Adding salt to the surface of your painting when it is wet produces an unusual texture that resembles small blossoms or starbursts. I have found that the best results are achieved when the paper is just losing its shine. One of the main uses of this technique is to suggest falling snow in a winter scene. The darker the color on which the salt is applied, the more visible the effect. There are different opinions on which type of salt to use, but I have found that regular table salt works fine.

Charging

Adding wet paint into the wet paint already on your painting is called *charging*. The key to charging color effectively is to drop colors into existing wet shapes in various places to create a variation of colors rather than brushing them in. Brushing two wet colors together will create a third color that has no variation.

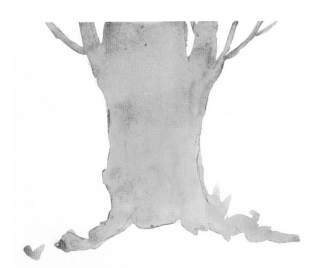

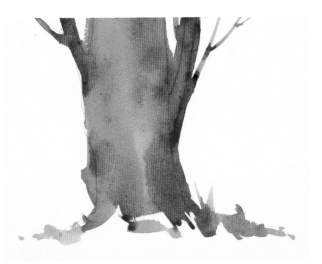

1 Paint a Shape
Paint a tree with a wet mix of yellow (I used Golden Lake) on dry watercolor paper.

2 Charge Wet Color Onto Wet Paint
While the tree shape is still wet, apply a wet wash of dark orange (I used Avignon Orange) in a few places. The two wet colors mix and dry to create a new color that is a combination of the two existing colors.

Glazing

When you *glaze* paint, you are applying a smooth wash of color onto your painting surface. You can glaze directly onto the paper and watch the white of the paper glow through your color giving it a luminosity similar to stained glass. Or you can glaze one color directly over another color to create more color excitement.

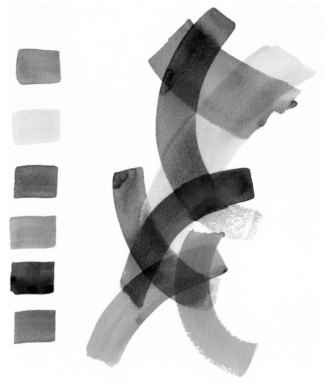

Glazing Transparent Colors
These colorful ribbons were painted with a 1-inch (25mm) flat brush and the following transparent colors: (from right to left) Primary Red-Magenta, Permanent Yellow Lemon, Primary Blue-Cyan, Orange Lake, Cupric Green Deep and Permanent Violet Blueish. Allow each glaze to dry before painting an additional color over it.

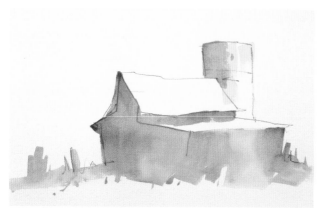

Apply an Initial Layer of Paint
Paint the sides of this barn and silo with a wet brown mix (I used Brown Stil de Grain) on dry paper. Leave white paper on the roof and on part of the silo to suggest light. Let this dry.

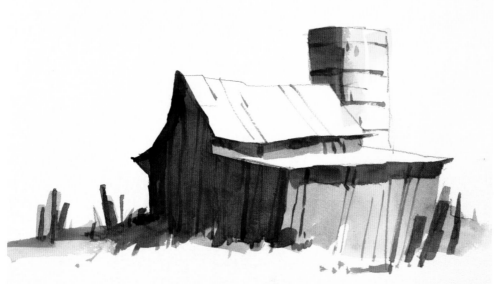

Glaze on a Second Color
Glaze a wash of violet (I used Permanent Violet Blueish) over the areas of the barn and silo that are not in direct light. Since the paper is dry, you will be able to maintain complete control of the shapes. Be careful to apply this glaze of violet with a minimum of brushstrokes so as not to disturb the underpainting. The transparent nature of the violet allows the brown to show through the paint creating a luminous quality.

Lost and Found Edges

Lost and found edges are an essential element of any painting regardless of the medium. In watercolors, however, they are particularly important because of the transparent nature of many of the colors. The terms *lost* and *found* refer to the process of either blending away a hard edge or leaving a hard edge. A hard edge is commonly used to draw attention to a specific shape or subject in a painting. It basically says "stop and look at me, I am something." A lost edge creates a gradual transition from one shape to another.

Create Hard and Soft Edges

The tree in this exercise is a white shape against a darker background. Suggest the hard edges of the tree by bringing the background color all the way to the edge of the pencil line. Then use a slightly damp bristle brush to blend away and soften the outside edge, creating a vignette look. To achieve a clean blending of an edge that you do not want, blend from the dry area into the wet area.

Waterfall Effect

Lost and found edges are used here to create the illusion of water falling off a rock formation. The soft edges of the water contrast against the harder nooks and crannies in the rock and help lead the eye through this painting.

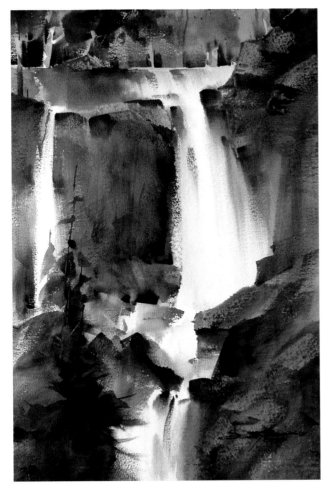

Near Home
Watercolor on 300-lb. (640gsm) cold-pressed Fabriano Artistico paper
22" × 15" (56cm × 38cm) • Private collection

Lifting

Lifting color is an effective way to introduce a lighter value shape in an area of the painting that is darker in value. The degree to which a color will lift depends on the individual color that is being lifted and the paper used for the painting. Some paper like Fabriano Artistico allows colors to be lifted easily (including staining colors). Test the paper and colors that you plan to use.

Dappled Light
Paint in a field of grass. When it dries, you can scrub out paint with a barely damp brush and blot with tissue to lift the color. The resulting effect appears as dapples of sunlight on the grass.

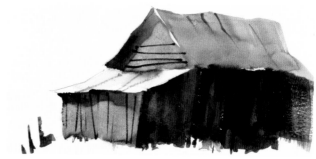

Strong Sunlight
Paint in a building using an overall dark color. Scrub away some of the dry color on one side of the building and then blot with tissue to lift some of the color and create the illusion of sunlight.

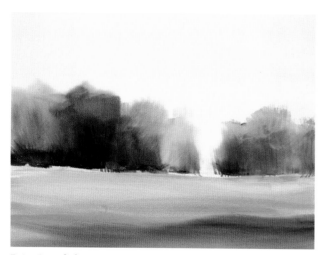

Paint Initial Shapes
Paint a soft backdrop in the overall shape of a stand of trees.

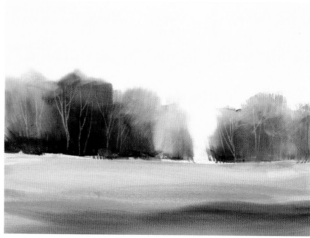

Add Detail With Lifting
Once the paint dries, use a rigger brush and clear water to make a few thin lines to suggest trees. Wait about five seconds and wipe these lines hard and vigorously with tissue to lift the paint.

Masking

Masking an area of your painting is an excellent way to preserve an area of lighter value or white paper while painting a darker value background. There are a variety of masking fluids and films on the market. I prefer to use fluid as I generally mask detailed areas rather than larger shapes.

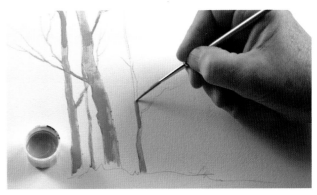

Apply the Masking Fluid
Use an old rigger brush to apply a heavy wash of masking fluid to a stand of birch trees. (I applied a little violet paint to the fluid to give it color.) Let this dry.

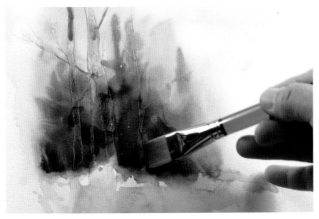

Set the Scene
Paint in the background and foreground right over the trees.

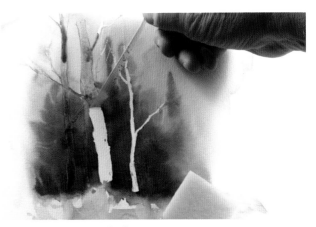

Remove the Masking Fluid
When the paint has dried, use a rubber cement pickup to remove the masking fluid and expose the white trees beneath. Do not leave the masking fluid on your paper for more than a few days.

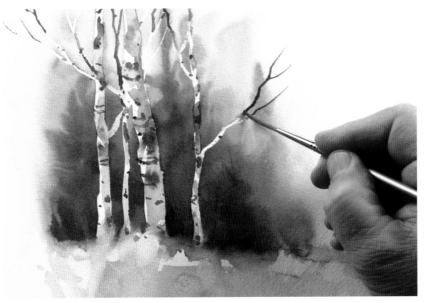

Add Final Details
Now you are free to add details to the trees, allowing them to sparkle in the sun against the darker trees in the background.

Tips for Working With Masking Fluid

- Always use an old or inexpensive brush.

- Add a little pigment to the masking fluid—this makes it easier to see, and it won't stain the paper.

- Before applying stir the fluid instead of shaking to avoid bubbles.

- Wash your brush thoroughly after use to remove as much of the masking fluid residue as possible.

Shape Painting

When painting with watercolors, remember that you cannot paint a light value over a darker value unless you are using opaque paint. If you are painting with transparent or semitransparent paint, apply the lighter values first and then paint the darker values around them. This is why it is so important to know how to identify which shapes are going to be positive shapes and which ones will be negative shapes.

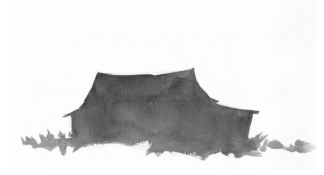

Positive Shapes
Positive shapes are the result of direct painting. Anytime you actually paint an object, it is a positive shape. Here, the barn is a dark shape against a lighter background.

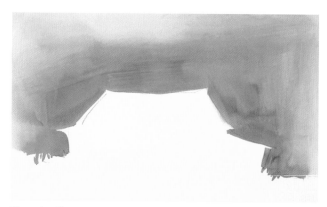

Negative Shapes
Negative shapes are shapes that are portrayed by painting the area around the shape to give it definition. The barn in this illustration is a negative shape, created by painting around the barn with a darker color.

Practice Shape Painting
This painting illustrates how effective negative shapes work for building depth in a painting.

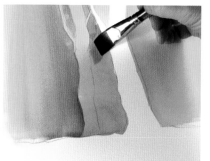

1 **Paint Between the Trees**
Pencil in a few tree shapes and then use a darker yellow-brown mix (I mixed Golden Lake and Brown Stil de Grain) to paint between the pencil lines thus creating negative tree shapes. Let dry.

2 **Establish a Base Color**
Leave the large white tree as unpainted paper and apply a wet yellow mix (I used Golden Lake) from one side of the painting to the other. Let dry.

3 **Finish the Painting**
Repeat the process and use an even darker mix of the two colors to paint between the tree shapes to create even more negative tree shapes. Add some positive tree shapes and use a light wash of color on the white tree to give it form.

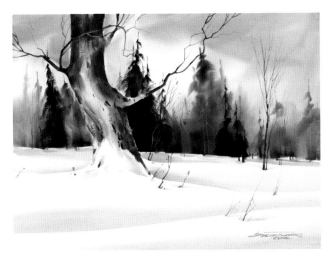

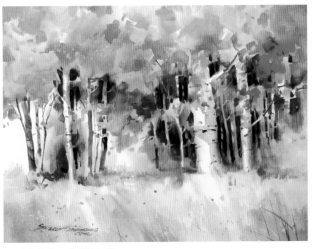

Create Smooth Transitions Between Shapes

The trunk of the large tree in this painting began as a negative shape by painting the dark background trees around the white shape of the large tree. Once the background color dried, I added color to the white trunk. The top of the large tree was painted as a positive shape against the light sky. A damp brush was used to soften the transition point where the negative shape and positive shape came together.

Standing Alone
Watercolor on 300-lb. (640gsm) cold-pressed Arches paper
15" × 22" (38cm × 56cm)

Establish Depth With Shapes

The autumn trees in this painting are mostly negative shapes. Even the distant trees farther back in the woods were suggested as negative shapes by placing a darker value on each side of the orange color. A few of the trees on the left side of the painting are painted as positive shapes.

October Joy
Watercolor on 300-lb. (640gsm) cold-pressed Fabriano Artistico paper
15" × 22" (38cm × 56cm) • Private collection

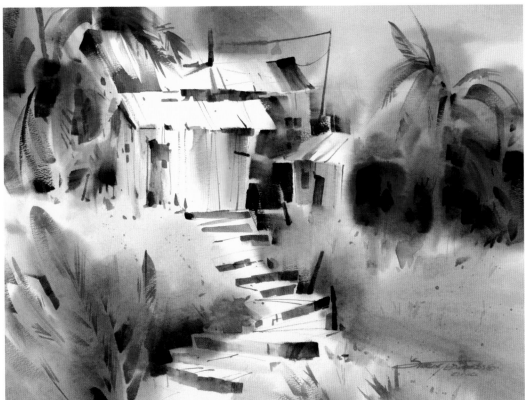

Save White Shapes

This simple study was painted mostly on wet paper. I was careful to paint around the buildings and leave them predominantly as a negative shape of white unpainted paper for most of the painting. When the paper was dry and all of the background colors and shapes established, I suggested a few architectural details to the buildings. I also used a negative painting technique to suggest general foliage.

Old Wood and Sheet Metal
Watercolor on 300-lb. (640gsm) cold-pressed Fabriano Artistico paper
15" × 22" (38cm × 56cm) • Private collection

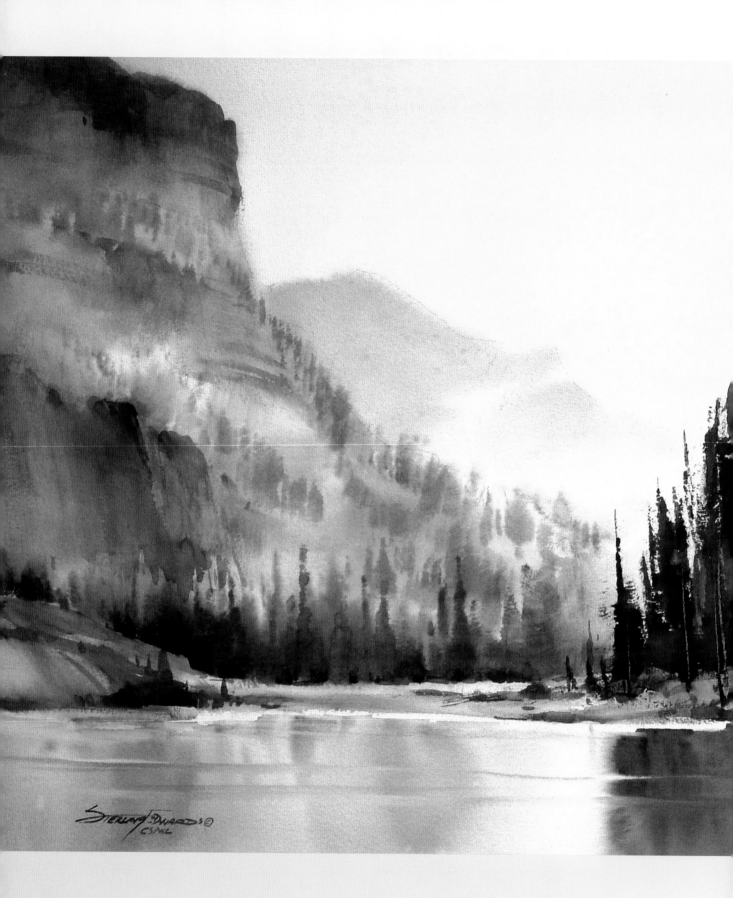

Composition

A strong composition is the backbone of your painting. When talking about composition, we are simply talking about the arrangement and organization of shapes, nothing more and nothing less. Since a painting is two dimensional and consists of little more than shapes and colors, it is important to arrange them in a manner that has balance and is aesthetically pleasing to the eye. A painting with a strong composition is much like the symphony—everything has a place and purpose that will ultimately contribute to the overall "sound" and visual interpretation of the painting.

Crooked Creek
Watercolor on 300-lb. cold-pressed Fabriano paper
22" × 30" (56cm × 76cm)

The Rule of Thirds

One of the most common and accepted guides for a strong composition is called the *Rule of Thirds*. Following this rule will allow you to direct your viewer through a painting to keep the eye moving to and from your center of interest.

By using one of the four junctions in the Rule of Thirds as the center of interest, we are able to create more off-balance varieties of shapes that stimulate the eye and the mind of the viewer. This is not to say that balance is not good in a painting. Balance can be achieved with the individual shapes within the composition once the location of the center of interest has been established.

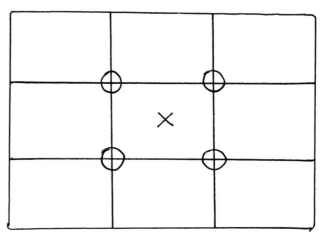

How Does the Rule of Thirds Work?

Divide the surface of your paper or canvas into equal thirds vertically and horizontally. This will result in a crisscross of lines resembling a tic-tac-toe board. Any junction where the lines connect would be an appropriate location for a center of interest. The center of interest is the heart of your painting and bears most of the weight of the design elements. Contrary to the name, the center of interest should not be placed in the center of your painting.

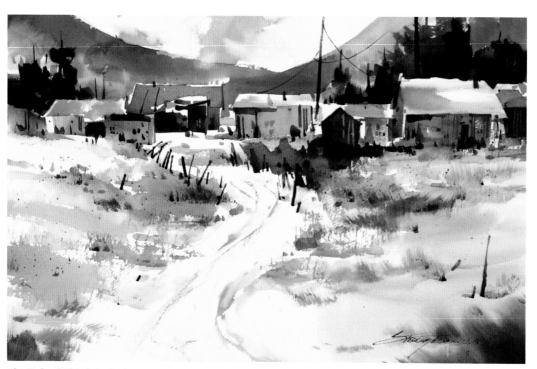

The Rule of Thirds in Action

In this painting the center of interest is in the upper right third of the composition where the white rooftop, the dark trees and the shadowed building reside. All other pieces of the painting direct the viewer to this area of high contrast—the road winds toward it, the light sky points down toward it.

Turquoise Trail
Watercolor on 300-lb. (640gsm) cold-pressed Arches paper
15" × 22" (38cm × 56cm)

Common Compositional Formats

Most artists use one of these five common compositional arrangements when painting. They are based on the Rule of Thirds and allow for interest, unity and balance—these arrangements are just generally pleasing to the eye.

Use these five basic compositions to manipulate shapes, rearrange subjects and embellish your paintings in a creative manner without violating any accepted design theories and rules.

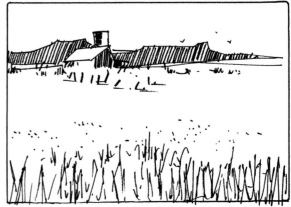

The High Horizon composition enables the artist to extend the foreground and middle ground farther and higher in the painting, resulting in a wide expanse of space that draws the eye to the center of interest in the upper left third of this example.

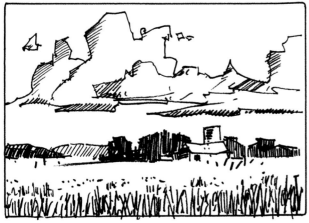

The Low Horizon composition lends itself to the illusion of open space. This composition is good when the sky is the center of interest.

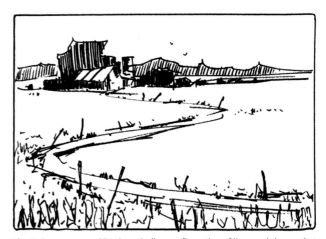

The S-Curve composition is a winding configuration of lines and shapes that takes the viewer to the center of interest. It can be combined with a high or low horizon. In this example the S-curve is used in a high horizon format.

The Tunnel composition typically uses light surrounded by dark to draw the eye to the center of interest. It can be combined with an S-curve or a high or low horizon composition. In this example it is used with an S-curve format.

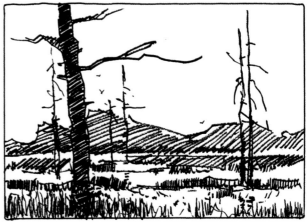

The Cruciform composition resembles a cross. It can be a high or low horizon composition. In this example it is used with a low horizon format.

Creating Interest With Variety

Variety is necessary for a painting to capture and hold the attention of the viewer. Variety comes in many forms ranging from values, colors, textures, edge quality, direction, size and weight. Adding variety to your paintings in conjunction with a strong center of interest and a balanced composition will elevate your paintings.

Wrong—Too even

Correct—Variation

Vary Sizes and Placement

Repetition can add an element of cohesiveness to a painting provided it has enough variety to be entertaining. The same shapes replicated in the same size and manner throughout a painting can easily become boring and monotonous. By varying the heights width and spacing between the fence posts they become an interesting addition to the painting because of an extra element of interest and movement.

Incorrect—Too much weight on the left

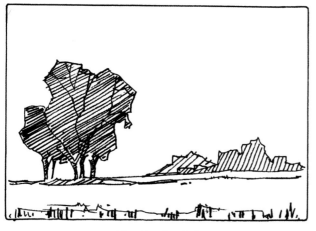

Correct—Good distribution of weight

Alter Weight of Shapes

An off-balance composition distracts the viewer and creates a sense of uneasiness. Too much weight or activity in one area of the painting without balance in the other areas is like looking at a crooked picture hanging on a wall. Most people will feel as if they need to straighten it. The sketch on the left is completely off balance because the shapes on the left side of the sketch contain a lot of weight while the shapes on the right side are smaller and lighter in weight.

Making the trees larger on the right side and varying their sizes redistribute the weight and make a more pleasing composition.

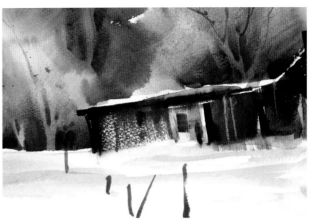

Combine Hard and Soft Edges

Combining hard and soft edges in the same shape creates drama and allows the eye to move into and out of the shape. The combination of the wet-on-wet and wet-on-dry painting adds variety.

Contrast Values

Variety can also be obtained by using contrasting values in the same or adjacent shapes. This painting has a multitude of value changes within the background and foreground areas ranging from dramatic to subtle, all serving to lead the eye and provide interest.

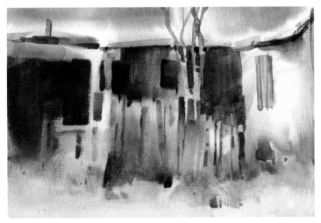

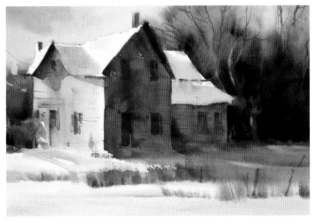

Create Color Transitions

Soft transitions from one color to another are what make watercolor so desirable and create a natural way to lead the eye through the painting.

Create Dynamic Lines

Vertical lines and shapes add an element of height and expectation to a painting. Horizontal lines and shapes add an element of stability and calm. Angular lines and shapes, commonly referred to as *obliques*, are the rebels that add a sense of drama and create a certain degree of friction in a painting. The shapes in this painting are entertaining because of the exaggerated oblique lines that give the buildings and fence character.

Compositional Do's and Don'ts

As artists we get so excited about the prospect of wetting the paper and diving into the paint that we don't take a few moments to stop and evaluate what we are about to paint. From a compositional standpoint this can be very detrimental to the finished painting.

Let's review some common compositional mistakes and how to fix them before you start painting.

Improper scale

Proper scale

Alter Size to Create Depth

The middle ground row of trees in the sketch on the left is the same height as the distant row of trees, creating a poor sense of scale and distance. Notice that both rows of trees are basically lined up across the top. This diminishes the appearance of distance and creates a boring division of space across the painting. The middle ground row of trees in the sketch on the right appears closer than the distant row of trees because it is larger. Notice that the tops of the rows of trees have more variety and are more interesting shapes.

Incorrect—The bottom of the cloud on the left is teetering on the tip of the lighthouse.

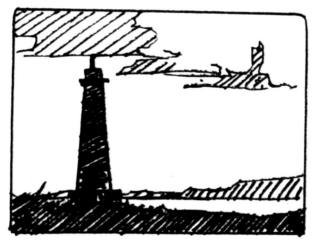

Correct—The cloud has been moved farther down to appear behind the lighthouse.

Overlap Shapes to Show Dimension

Overlapping shapes adds dimension to a painting. The tip of the lighthouse on the left is a source of tension where it balances the bottom of the cloud. It also creates an area of the painting that appears flat and uneventful. All that was necessary to remedy this situation was to apply a little artistic license and move the cloud farther down in the sky creating a nice overlapping of shapes with more depth.

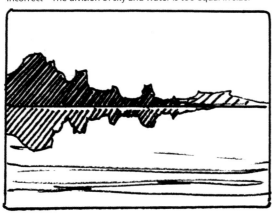 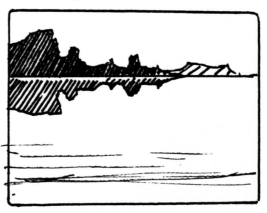

Avoid Equal Divisions of Space

It's always a good idea to avoid dividing your paper into equal parts regardless of what you are painting. This is particularly true when painting bodies of water. Since the horizon line on a lake or ocean scene is always level, it should be placed either above or below the center of the paper to avoid creating an equal and boring division of space.

Incorrect—Water level is uneven defying the laws of nature.

Correct—The waterline is level.

Keep Water Level

A beautiful lake or ocean scene can easily be ruined if the waterline is not level. It's a good idea to use a ruler when designing this type of painting to be sure that everything complies with the laws of gravity. If the finished painting has a waterline that is slightly off level, it can be corrected with creative matting.

Incorrect—The line from the road directs the eye out of the picture.

Correct—The line avoids the corner and directs the eye into the painting.

Don't Let the Eye Leave the Painting

Anytime there is a line that takes the eye directly into the corner of a painting, it acts as an arrow taking the eye away from the painting. This can easily be remedied by moving the line up or down a little to prevent it from going directly into the corner. When the line is moved, the edges of the painting act as roadblocks and stop the eye from exiting the painting.

Composing With Photographs

Most photographs contain too much information and to try and paint them can seem overwhelming. The philosophy that I follow and teach is simply to make the object that first attracted you to take the photograph your center of interest. Then merely suggest the other subjects to a lesser degree to not compete with the center of interest.

It's OK to leave some of the subjects out of the painting or to move them within the painting. It's also quite acceptable to add something to the painting if it will strengthen the composition or add more interest to the overall appearance. It's also OK to break away from the local colors in the photograph.

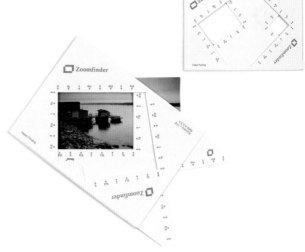

Photo Cropping Made Easy

One of the best ways to center in on your subject and eliminate much of the unwanted clutter in a photograph is using a tool called a Zoomfinder. This incredible tool usually costs little and is available in many art supply stores. It consists of two pieces of plastic that slide back and forth creating two apertures, one square and the other rectangular. By sliding the top piece you can change the size of the apertures to accommodate the shape and image you are viewing within a photograph.

Combine Images to Improve the Composition

Quite often we find an exceptional shape in nature that we can include in a painting to add an element of drama, style, color, intrigue or balance. This is why I usually keep a camera on hand when I'm out because I never know what I may run across. I have hundreds of photographs of trees, rocks, buildings, clouds, mesas and just about anything else you can think of that could add to the quality of a composition.

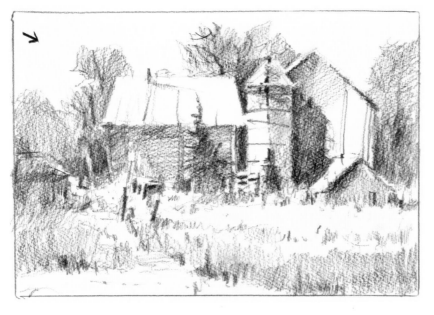

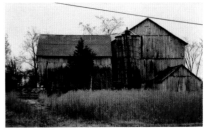

Add a Light Source

This photograph of a barn in Ontario, Canada, has some beautiful shapes but no real light source. Nevertheless, it has some interesting overlapping shapes that gave me an idea for a painting.

By adding a light source into the scene you see immediate improvement in the drama of this scene.

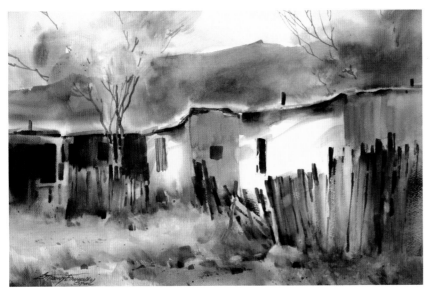

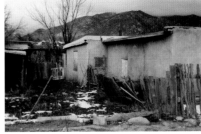

Pump up the Color

By taking a little artistic license with color and light I was able to create an exciting and loose painting using the shapes in the photograph as inspiration. I added a few more suggestions of the trees and added a little color to make things more visually appealing.

I suggested a little bit of light hitting the front of the building. All it took was a few cast shadows to tell the viewer that there is a little sunlight in the scene.

Without the additional colors and suggestions of light the painting would be relatively flat and lifeless. The painting is still a representational depiction of the scene as I saw it, but now it is a little more entertaining.

Value Studies: Your Road Map to Success

Every painting needs a plan, even if it's just something you envision in your mind. Without a plan we are just pushing paint around on a piece of paper in hopes that something will develop. So many questions must be asked and answered, such as where is the center of interest, from which direction is the light or is there any defined light, where should I place the darkest darks, what colors should I use?

All of these questions can be answered by doing a value study. *Values* (the lights and darks of your painting) will give your painting dimension and strength. Once you plan the values, your painting will go somewhat on autopilot; all that remains is the selection and application of color.

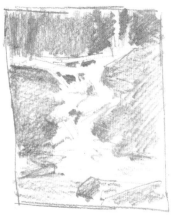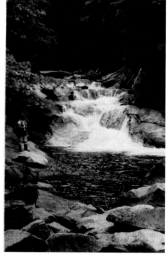

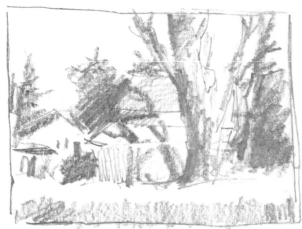

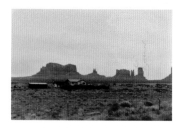

Create a Thumbnail Sketch

Thumbnail sketches take only a few minutes to produce and provide a wealth of information. All the studies above are glimpses of potential paintings composed from reference photographs. Some scenes have been isolated with the help of a viewfinder. In several of the studies items have been moved or removed, or new items added.

Doing a value study in pencil is an opportunity to play with design and spatial relationships. It's not necessary that you labor over these, but you may find it useful to do as many as eight or ten value studies of the same subject using a different arrangement each time. Then pick the one that best suits your needs and start painting.

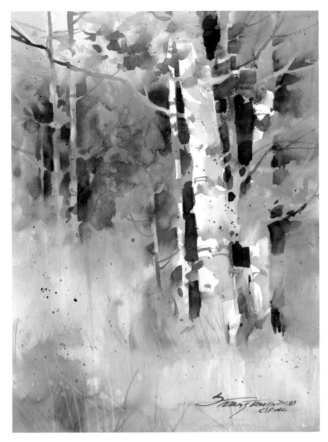

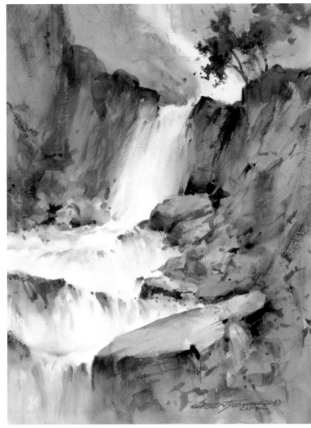

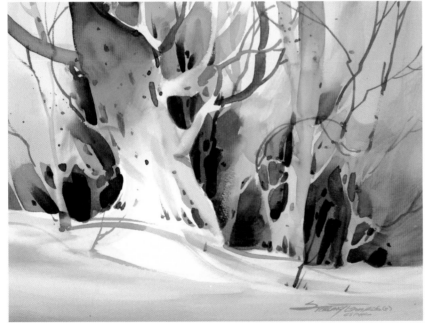

Create a Monochromatic Value Study

A monochromatic value study is an excellent way to judge the balance of light and dark because it is painted in just one color so you do not become distracted by a variety of colors. It really is your road map to success because when you have finished the value study, most of the design problems have been worked out.

Once you have completed a monochromatic value study, it can be reused as often as you like with a different painting emerging each time by merely changing the colors in each painting.

When you learn to recognize and organize values, you'll be amazed at the difference it will make in your paintings. Quite often I paint a scene solely from the information in the monochromatic value study, rather than use the photograph as a reference tool.

Painting a Monochromatic Value Study

This is an interesting subject because it has both weight and delicacy. The values are strong and an assortment of hard and soft edges allow the eye to travel through the scene.

MATERIALS LIST

PAPER
11" × 15" (28cm × 38cm) 140-lb. (300gsm) cold-pressed Fabriano Artistico paper

PAINTS
MaimeriBlu Green Blue

BRUSHES
½-, 1- and 2-inch (13mm, 25mm and 51mm) flats
1-inch (25mm) stiff bristle
no. 8 round
no. 6 rigger

OTHER
2B pencil

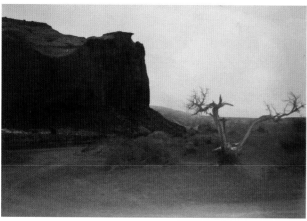

Reference Photo

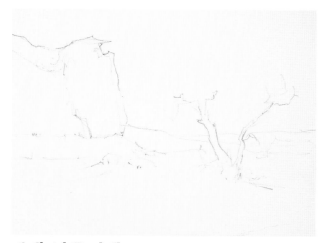

1 Sketch Simple Shapes
Using a 2B pencil, sketch the larger shapes on a piece of dry paper.

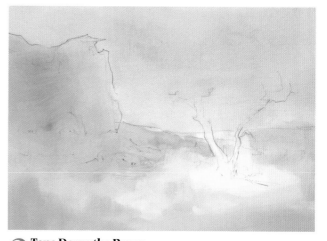

2 Tone Down the Paper
With a 2-inch (51mm) soft flat brush, apply a wet wash of Green Blue paint on the entire surface of the paper except for the area of the tree. The purpose of this step is to tone down everything except for the area of the center of interest, which in this case is the area at the base of the tree. With a barely damp 1-inch (25mm) bristle brush, soften the edges around the center of interest.

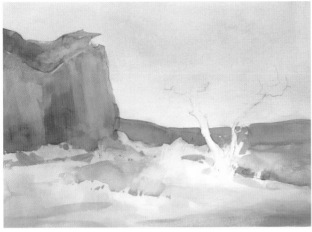

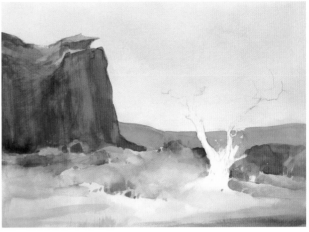

3 Establish Large Shapes

While the paper is still slightly damp, use a 1-inch (25mm) flat and the same color with less water and begin to add slightly darker values to establish some of the shapes in the painting. Do not concern yourself with any detail at this time, but instead focus on the larger shapes. When this step is completed, dry the paper thoroughly.

4 Add Midtones

With a 1-inch (25mm) flat brush keep adding midtones to the mesa to build up the shape. The distant ridge behind the tree can also be painted at this time using a ½-inch (13mm) flat brush. Paint around the tree trunks leaving them white as negative shapes. Use a slightly damp bristle brush to soften some of the edges of the shapes.

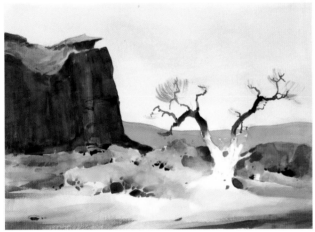

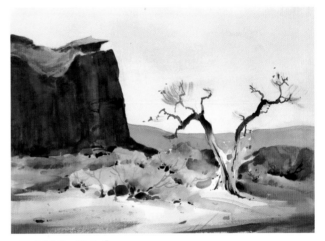

5 Start Adding Darks

Add the darks by mixing heavy washes of the color that have very little water using the 1-inch (25mm) flat brush and the no. 8 round brush as needed. The areas beneath the scrubby bushes are treated with a little dark value to produce negative shapes of the structure of the bushes. Use the damp bristle brush to soften some of the edges. The upper tree branches that are silhouetted against the sky are painted using a rigger brush and a dark mix of the Green Blue paint to maximize the contrast. Use the damp bristle brush to blend the connection point where the dark upper tree trunks join the negative tree trunks below.

6 Add the Details

Use the rigger brush to add details such as the branches of the bushes, the small tree branches and a few cracks in the wall of the mesa. The rigger brush is also excellent for applying splatter at the end of your painting to suggest pebbles and sand. Protect the sky area with a piece of paper. Load the rigger brush with a wet mix of color, tap the brush lightly over your palette to remove any excess paint, and gently tap the brush while holding it over the area that you want to splatter.

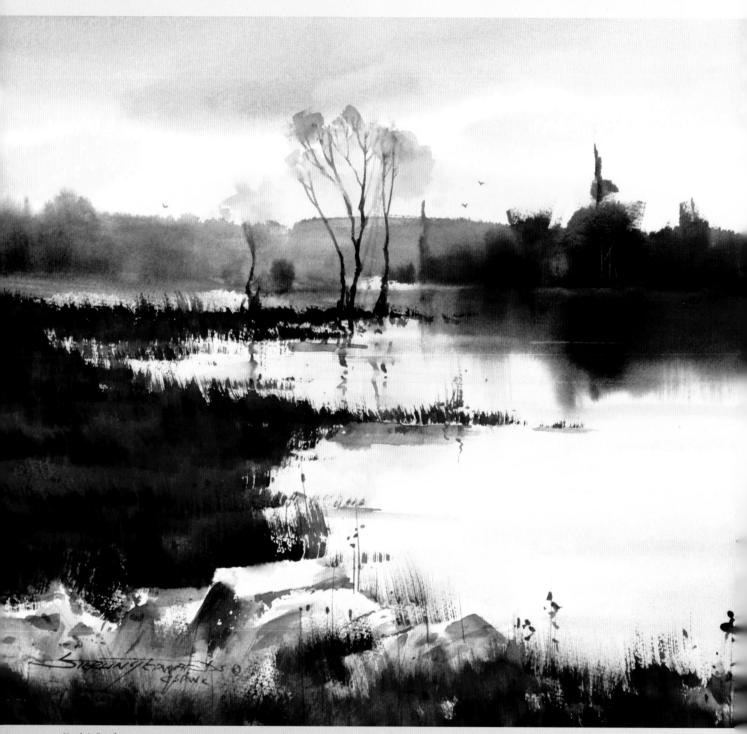

Nogie's Creek
Watercolor on 300-lb. (640gsm) cold-pressed Fabriano paper
15" × 22" (38cm × 56cm) • Private collection

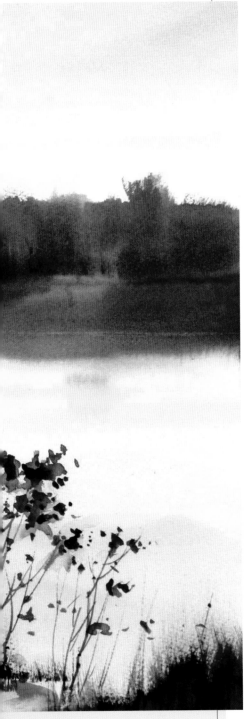

5

Painting Landscape Elements

When you paint a landscape, you are really painting a variety of shapes that convey a visual record or memory of a specific place. Quite often you might be painting a place that doesn't even exist, but as a landscape artist you are expected to produce paintings with shapes and elements that the viewer can readily identify and relate to.

This section of the book will cover how to paint a wide variety of these landscape elements. When choosing a subject for a painting, be totally honest with yourself about your ability to accurately paint each of the elements in the painting with the same degree of skill. For example, you might be very proficient at painting skies but have difficulty painting a building. Perhaps it would be more productive and less frustrating to leave the barn out of the painting until you have learned to paint a barn with the same level of proficiency as the sky. Use this section of the book to pick and choose the areas where you need the most help. Each of the demonstrations focuses on one element of the painting to keep the learnings more bite-size, but they are shown as small landscapes with multiple elements so you can see how these elements would be incorporated into a larger landscape painting.

Painting each element with the same skill level as opposed to tackling a painting with numerous elements all at once is a great place to start. This is the same process that I teach and encourage at my watercolor workshops. Over the years I have seen many wonderful artists evolve using this process. Once you have become proficient with a few individual landscape elements, you can move on to the final chapter where you will learn to place two or three elements in your painting to create luminous landscapes.

Rocks

Rocks come in just about every shape, size and color imaginable. Some are rounded whereas others are very angular. One thing they have in common though is that they are all a three-dimensional objects. They typically have a light side and a dark side depending on the light source. When painting rocks, it's important to emphasize the differences in light and dark to give the rock the weight and dimension that allow the viewer to properly assess and interpret the shape. Otherwise, it will appear as a lifeless blob of color.

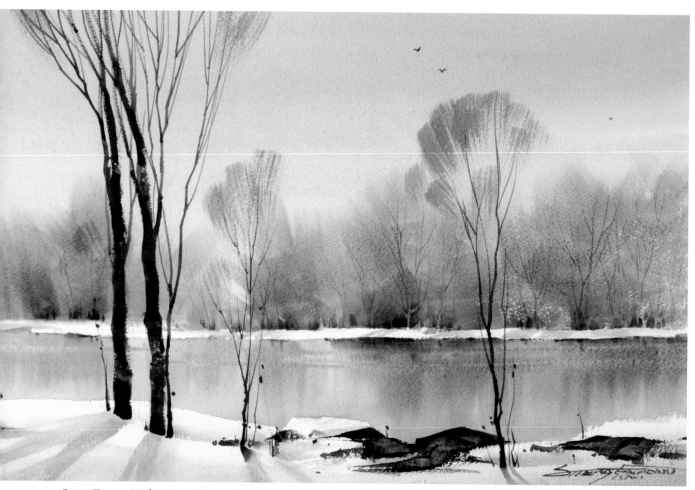

Create Texture With Unique Materials
The rocks in this painting were made with a credit card. First I suggested a few rocks with a 1-inch (25mm) flat brush, then I used a credit card to scrape away and push aside some of the color just before it dried. The scraped shape combined with the rough texture of the paper resembles a rock.

Looking Across
Watercolor on 300-lb. (640gsm) cold-pressed Fabriano paper
15" × 22" (38cm × 56cm) • Private collection

Painting Rocks With a Credit Card

One of the easiest and most expressive ways I have found to paint rocks involves using a credit card as a squeegee to push semi-wet paint aside on a rock shape. I use this approach more than any other in my loose watercolor landscapes because the transparent washes of heavy color leave a colorful, luminous residue when displaced by the credit card.

MATERIALS LIST

COLORS
Blue
Orange
Reddish Brown
Violet

BRUSHES
1-inch (25mm) flat
no. 6 rigger

OTHER
Credit card

1 Paint Rock Shapes
Paint the rock shapes using a 1-inch (25mm) flat and heavy mixes of color. Begin with orange, then while the shapes are wet, introduce random and varied dark touches of blue, reddish brown and violet. Allow the colors to mix on the wet paper and work quickly so the shapes do not dry.

2 Scrape Away Color
When the paint starts to lose its shine, use a credit card as a squeegee to displace some of the paint on the surface. As you pull the credit card, focus on making rock shapes, overlapping shapes as you drag through the paint. Each time you lift the credit card from the paper, it will leave a deposit of paint that resembles cracks and crevices in the rocks.

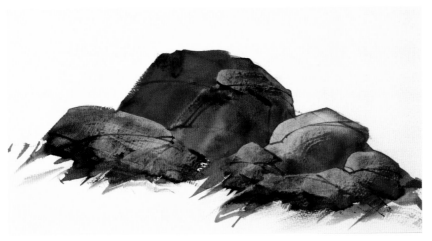

3 Add Texture Details
Finish the rocks on dry paper by adding additional cracks and crevices with a no. 6 rigger brush and a dark mix of some of the colors that were used to paint the rocks. You can also use a slightly damp brush to wipe any unwanted hard edges. Traces of the original colors will remain in the paper as light accents while the dark paint that was first applied suggests shadows on the rocks.

Rounded Rocks

It's easiest to portray the rounded shapes on this type of rock if you use a round brush. The size of the brushes you use will usually be determined by the size of the rocks you are painting and the size of the painting itself. To achieve a soft gradation from light to dark as the light rolls across the contours of the rock, you'll use a clean wet brush to blend the edges of some of the shapes while they are still wet.

MATERIALS LIST

COLORS
Blue

Reddish Brown

Violet

BRUSHES
no. 6 rigger

no. 12 round

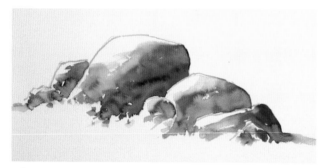

1 Lay in Base Color, Wet-On-Wet
Use a no. 12 round brush to paint large and small rock shapes on dry paper with a wet mix of reddish brown. While the shapes are still wet, introduce some violets and blues here and there to give the rocks a mottled look. Leave the tops of the rocks unpainted to suggest sunlight. As you move down the rocks toward the bottom, use a little darker value to give the rocks more dimension. At the base of the rocks, leave the edges ragged to suggest that the rocks are nestled in the grass. Let dry.

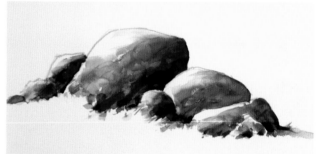

2 Add Shadows
Darken the areas that are away from the light with darker mixes of the initial colors. Use a clean, moist round brush to soften some of the edges of the darker shapes as you move toward the light on the tops of the rocks.

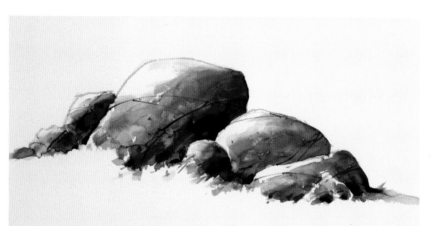

3 Add Texture Details
Finish the rocks by suggesting the texture of cracks and spots with a no. 6 rigger brush and a dark mix of violet and brown.

Angular Rocks

Angular rocks are painted with the same attention to light and shadow as rounded rocks. The main differences are the outside edge design of the rocks and the degree to which applications of color are softly blended to convey an illusion of contour. Angular rocks have more sharp edges than rounded rocks and should be painted in such a way as to illustrate this feature. Using a flat brush to paint most of the shapes will help ensure an angular look.

MATERIALS LIST

COLORS
Blue

Reddish Brown

Violet

BRUSHES
1-inch (25mm) flat

no. 6 rigger

1 Lay in Base Color, Wet-On-Wet
Use a 1-inch (25mm) flat brush to paint a wet mix of reddish brown on dry paper, being careful to keep the tops of the rocks unpainted to suggest sunlight. While the shapes are still wet, apply violets and blues in a few areas to vary the colors of the rocks. Use rough brushstrokes at the bottom of the rocks to help create the illusion the rocks are nestled in grass. Let dry.

2 Add Shadows
Paint the shadow sides of the rocks with a 1-inch (25mm) flat brush using darker mixes of the initial colors. Allow some of the brushstrokes to follow the jagged fractures of the rocks.

3 Go Darker and Add Texture Details
Add even darker darks to the rocks with heavier mixes of the colors from step 1. Use the darker values to differentiate between the individual rocks. Allow some of the brushstrokes to define the angular fragments of rock.

Finish the rocks with a no. 6 rigger brush and a dark mix of the brown, violet and blue to suggest cracks in the rocks and individual blades of grass.

Painting Skies

Let's face it, everyone loves a beautiful sky. Each one is as different as those who admire them. Painting skies can be a challenge depending on the particular type of sky you are painting. Sunsets, thunderheads, skies with rays of sunlight and many more have distinguishable characteristics that require special techniques to capture the drama and magnitude of the scene.

Usually I do not spend a great deal of time painting the sky in my landscapes because I look at the sky as a backdrop for the shapes and colors in the rest of the painting. Something as simple as a quick wash of color is often all that is necessary to suggest the sky without having it compete with the main subject of the painting. Other times, however, the sky is the main focus of the painting.

Once you have learned to paint skies, try experimenting with different colors and brushstrokes.

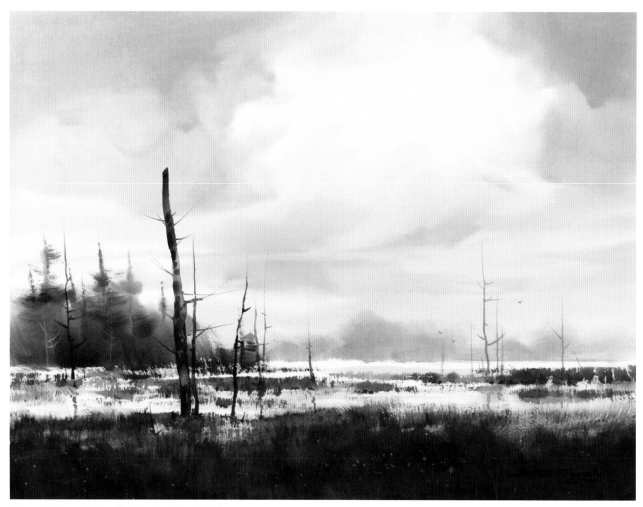

A Low Horizon Makes the Sky the Focal Point
The sky is the main subject of this painting and sets the mood for the entire scene. The large cloud formations in the distance suggest a hazy dawn or dusk setting. Because the shapes in the sky are significant, simply altering the color scheme to a gray or blue could suggest a pending storm.

Standing Watch
Watercolor on 300-lb. (640gsm) cold-pressed Fabriano Artistico paper
22" × 30" (56cm × 76cm)

Clear Skies

Clear skies are probably the easiest skies to paint. Most often they consist of a graded wash of color that is a little darker at the top of the painting and lighter at the bottom near the horizon. As you progress down the painting to the horizon, the brush will naturally hold less and less paint until there is very little paint left in the brush by the time you reach the bottom. If painted on wet paper, the effect is a smooth and gradual application of color as seen on a clear day when there are no clouds in the sky.

MATERIALS LIST

COLORS
Blue
Green-blue

BRUSHES
1-inch (25mm) flat
1-inch (25mm) stiff bristle

Create a Wash in the Sky

Wet the paper from the top to the horizon being careful to wet around the foreground mesa area. Establish your horizon line and wet the paper thoroughly from the top of the paper to the horizon line. Use your 1-inch (25mm) flat brush to wash on a wet mix of blue and green-blue, starting at the top of the painting and working downward. And that's it. Make sure to let the paper dry before adding in the rest of your landscape.

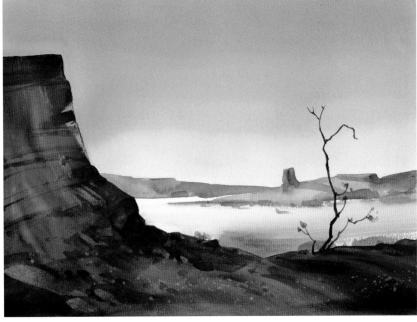

The Finished Painting

A Little Lonely
Watercolor on 140-lb. (300gsm) cold-pressed Fabriano paper
11" × 15" (28cm × 38cm)

EXERCISE

Clouds

MATERIALS LIST

COLORS
Blue
Gray
Green-blue

BRUSHES
½- and 1-inch (13mm and 25mm) flats
1-inch (25mm) stiff bristle

OTHER
Tissue paper

As an artist it's important to understand the physical characteristics of clouds. Even though clouds are composed solely of water vapor, they are three dimensional—establishing a light source will give your clouds shape. Also, most clouds have some color, which is dictated by the location of the sun.

I rely on two different ways to suggest clouds. One method is to treat the clouds as negative shapes and paint around them with a darker color. The other method is to use a piece of tissue paper to blot and lift some of the blue sky color to suggest a cloud. Both work quite well and I often combine the two methods in one sky.

1 Lay in Initial Sky Wash

Establish your horizon line, then wet the paper thoroughly from the top of the paper down to the horizon with a 1-inch (25mm) flat brush. Before the paper dries, apply a wet mix of blue and green-blue from the top of the paper working downward. Make the area of sky along the horizon lighter than the upper parts of the sky.

Apply a few level streaks of a fairly dry blue-gray mix across the lower part of the sky. These will become the shadows underneath the clouds.

2 Create Cloud Shapes

While the paper is still wet, use a ½-inch (13mm) flat brush to paint around the shapes that will be clouds with a drier, darker mix of blue and green-blue. Use a 1-inch (25mm) stiff bristle brush to soften some of the edges. Then use a wadded-up piece of tissue paper to suggest small, wispy clouds by pressing the tissue on the wet blue sky and lifting some of the blue color. Let dry.

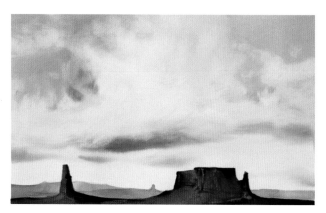

3 Develop the Cloud Shapes

Use a damp 1-inch (25mm) bristle brush to lift highlights on the side of the clouds facing the light, scrubbing the color and blotting with tissue paper. Notice how much color the clouds in the demonstration have. Even though we think of clouds as being white, there is actually a lot of soft color and volume in these clouds. The addition of the dark shadows beneath the clouds also adds to the three-dimensional illusion.

EXERCISE
Sunsets

I think sunsets are where Mother Nature shows us who the real artist is! Quite often sunsets are a variety of colors that are natural complements side by side in nature but can become muddy in a painting. A good example is a sunset that has a lot of orange and blue. Since orange and blue are opposite on the color wheel, they will gray down and get muddy or opaque if mixed together. To prevent the two colors from getting muddy you can place a third compatible color between them. In the case of orange and blue, magenta would be a good color to use as this third color. When mixed with blue it becomes a beautiful crimson, and when mixed with orange it becomes a fiery red-orange. I call these third colors *buffers*.

MATERIALS LIST

COLORS
Blue

Magenta

Orange

Violet

Yellow

BRUSHES
½- and 1-inch (13mm and 25mm) flats

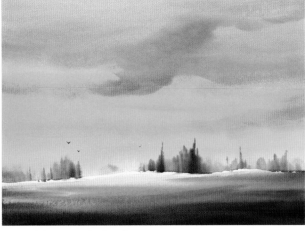

1 Wash in a Color Gradation

Establish a horizon line, then wet the sky area from the top of the paper to the horizon line. Begin painting the sky at the horizon with a wet, heavy yellow mix, using a 1-inch (25mm) flat brush and horizontal strokes to move the color from the horizon toward the middle of the sky.

While the sky is still wet, apply a wet orange mix over the top of the yellow and upward.

While these colors are still wet, apply a wet magenta mix from the top of the orange upward. Then apply a wet blue mix at the top of the paper, brushing down into the magenta to create a gradual transition of color. Work quickly and get all four colors in the sky before the paper dries.

2 Add Wisps of Clouds

While the paper is still wet, use a ½-inch (13mm) flat brush to apply a dry orange-violet mix to suggest a few wispy clouds near the horizon. Repeat the clouds as you move higher in the sky, adding a small amount of blue to the mix.

Stormy Skies

Stormy skies are often very dramatic and somber. The best stormy skies I paint are usually painted on wet paper that is tilted to allow the wet washes of color to run down the sky toward the horizon. The transparent, luminous watercolor leaves soft veils of color suggesting an atmospheric condition you might see during an oncoming storm. These are literally "get in and get out" types of skies—going back into the shapes may give the sky an overworked appearance.

MATERIALS LIST

COLORS
Blue

Gray

Reddish Brown

Violet

BRUSHES
½- and 1-inch (13mm and 25mm) flat

no. 6 rigger

1 Paint the Base Sky and Cloud Masses
Establish a horizon line and wet the paper from the top down to the horizon line. With the paper slightly tilted toward you, lay a light blue wet wash into the sky with a 1-inch (25mm) flat brush, starting at the top of the paper, working down to the horizon line.

While the paper is still wet, use the same brush to apply a semi-wet mix of gray-violet for the dark cloud mass, starting at the top of the paper and working down. Overlap some of the brushstrokes to give the clouds some movement.

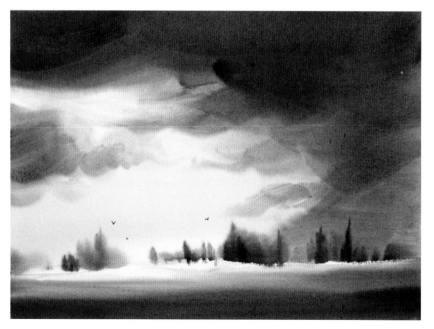

2 Intensify the Clouds
While the paper is still wet, use a 1-inch (25mm) flat brush to apply a drier, darker mix of gray-violet by adding some reddish brown to the mix. Overlap and vary the mixes of paint with a 1-inch (25mm) flat to get a turbulent look in the sky.

Rays of Sun

I usually do not put rays of sunlight in my paintings because they tend to become the dominant element in a painting. However, this is a beautiful effect and can add a great deal of drama to a painting. If you do choose to add sun rays, just add a few—too many can dwarf everything else in your landscape. Always remember that with this and any other special effect, moderation is the key to good taste and success.

MATERIALS LIST

COLORS
Blue
Gray
Violet

BRUSHES
1-inch (25mm) flat
1-inch (25mm) stiff bristle

OTHER
Hair dryer
Masking tape
Tissue paper

1 Paint the Sky

Establish a low horizon to show more sky, and wet the paper thoroughly from the top down to the horizon line. Lay wet washes into the sky with blue, violet and gray using a 1-inch (25mm) flat brush. Soften the bottom edge of the color with a damp bristle brush as it approaches the horizon.

Paint in darker clouds on the still wet paper with a wet, darker mix of the same colors. Vary the mix as you paint to give the sky some movement. This same mix can also suggest a distant tree line on the horizon. Let dry.

2 Mask Around a Ray

Put two pieces of masking tape on the paper and use a soft damp brush to gently moisten the color between the tape—this will be the ray of sun. Wait a few seconds and use a piece of tissue paper to blot the loosened color. Let this dry, then apply heat to the tape with a hair dryer and peel the tape away. The heat will help loosen some of the adhesive on the tape resulting in easier removal.

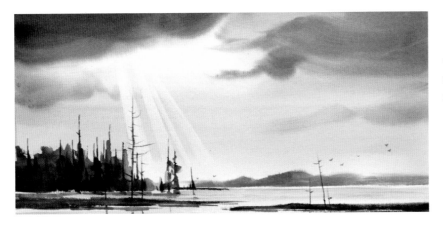

3 Add a Few More Rays

Repeat step 2 four or five times being careful to vary the space between the shafts of light and varying the width of the shafts.

Mountains

Mountain scenes can be breathtaking, solemn, mysterious or spiritual depending on the type of mountain and the manner in which it is painted. I live in the Smoky Mountains of North Carolina and never cease to be amazed at the beauty and mystery of the fog-filled valleys, rocky streams and lush green hills. It's no wonder that so many artists, including myself, love to paint mountains.

No matter what kind of mountain you are drawn to paint, you'll want to accurately portray the size and scale of the mountain. To do this there needs to be something else in the painting that is easily recognizable. Many painters include a small image of a person or animal in their painting to help the viewer determine the scale of the mountains and vista in the painting. Viewers can identify with the figure and determine the relative size of everything else in the painting.

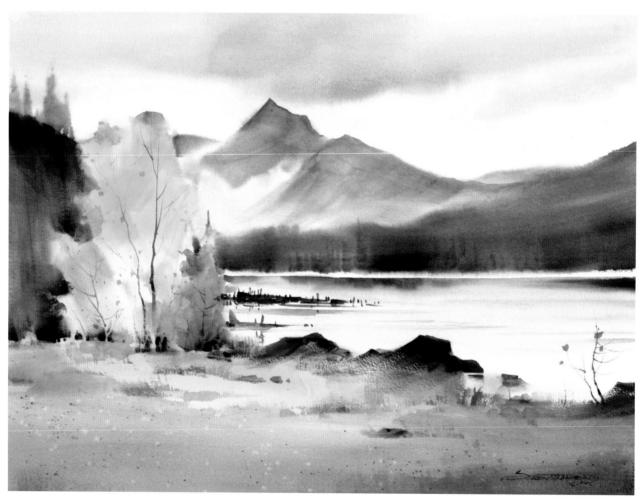

Focus on Large Shapes First, Then Add Detail
Mountain scenes are made up of primarily larger shapes. Use 1- and 2-inch (25mm and 51mm) flat brushes to capture the dynamics of a subject while avoiding unnecessary detail. In this painting, the sky, mountains, river, foreground tree and grassy area were all painted quickly with larger brushes. After the largest elements dry, use smaller brushes to add definition and draw attention to specific elements of the painting.

Majestic
Watercolor on 300-lb. (640gsm) cold-pressed Arches paper
22" × 30" (56cm × 76cm)
Collection of the artist

Snow-Capped Mountains

Snow-capped mountains capture a sense of monumental scale unlike any other landscape subject and have a natural tendency to mesmerize the viewer. As with most snow scenes painted in watercolors, the white paper is the snow. The main concern is to establish a light source and include the appropriate shadows. Another area that needs to be executed properly to create the illusion of monumental size is a system of smaller shapes that recede in the distance. The foreground and middle ground shapes and values are an integral part of any composition, but they are especially important in a mountain scene because they, more than anything else, tell the viewer just how big the mountain is.

MATERIALS LIST

COLORS
Blue
Gold
Gray
Green
Yellow

BRUSHES
½- and 1-inch (13mm and 25mm) flat
1-inch (25mm) stiff bristle
no. 6 rigger
no. 8 round

1 Establish the Mountain Shape
Give shape to the white mountains by adding shadows and rock formations to show where they angle and overlap. Use dark combinations of gray and blue, softening an occasional edge with a barely damp 1-inch (25mm) stiff bristle brush.

Use a no. 8 round brush and varied mixes of yellow, gold and green to suggest small trees at the base of the slopes.

2 Develop Mountain Shape and Scale
Continue adding shadows and rock formations on the mountains along with more small trees on the slopes and in the middle ground using the same dark mixes from step 1.

3 Intensify the Illusion of Depth
As you come down to the foreground, making the trees larger will help add even more to the illusion of depth, as will adding more foreground details such as grasses.

Distant or Foggy Mountains

MATERIALS LIST

COLORS
Blue
Gray
Green
Light Yellow
Reddish Brown
Yellow

BRUSHES
1-inch (25mm) flat
1-inch (25mm) stiff bristle
no. 6 rigger

Distant mountains are best portrayed by adjusting the values of the mountain shapes from darker values in the foreground and middle ground to progressively lighter values as objects recede in the distance. This phenomenon, called *aerial perspective*, occurs as the water in our atmosphere grays down colors as they recede in the distance. Foggy shapes are also gray and have muted color even though they may be fairly close to the viewer. Controlling the value of the shapes and blending edges will tell a very convincing story of a foggy or distant mountain scene.

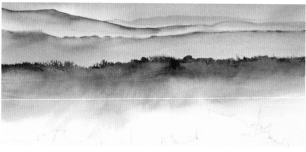

1 Establish Rows of Mountains

Wet the top half of the paper and use a 1-inch (25mm) flat brush with wet washes of gray, blue and reddish brown to suggest a sky. Keep the sky light in value and soften the bottom edge with a damp, stiff 1-inch (25mm) bristle brush. Let dry.

Use a 1-inch (25mm) flat brush to paint a faint distant hill with a light, wet blue-gray, softening the bottom edge with the bristle brush. Dry the paper and repeat the process adding a little more value and color as you come closer.

Toward the middle of the painting add a little green to the mix to darken the mountain and show more of the tree colors as they get closer. Use a flat brush to scumble the top of the mountain to suggest trees.

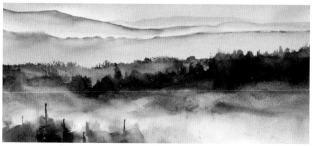

2 Come Closer

Paint the next closest mountain with an even darker mix of the blue, gray and green, paying attention to the tree shapes at the top of the ridge and blending out the lower edge. Use the flat brush to lift some of the wet color from the shape to suggest veils of fog.

Paint the next closest trees with varied mixes of this dark green, adding in yellow to brighten and show that these trees are closer and not enshrouded in the fog.

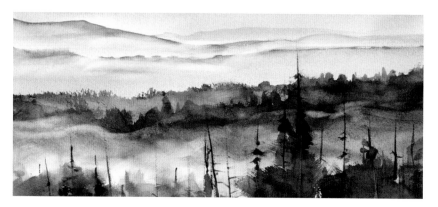

3 Establish Scale With the Foreground

Finish the painting with large foreground trees and detailed grasses using a no. 6 rigger brush and varied mixes of gray, green and reddish brown for the trees and a mix of light yellow, green and gray for the grass.

Rocky or Jagged Mountains

Rocky and jagged mountains are fun to paint because they allow the artist an opportunity to play with color, value and most of all edges. To convincingly tell the viewer that the mountain is jagged, there have to be sharp edges on many of the rocky shapes. It's also necessary, however, to balance the jagged sharp edges with softer edges elsewhere in the painting. It's the combination of extremely hard edges fused with soft, integrated shapes that makes these paintings so dramatic.

MATERIALS LIST

COLORS
Blue
Gold
Green
Green-blue
Orange
Violet
Yellow

BRUSHES
½- and 1-inch (13mm and 25mm) flats
1-inch (25mm) stiff bristle
no. 8 round

1 Establish the Mountain Range

Paint in overlapping mountain shapes with a 1-inch (25mm) flat brush and light mixes of orange, gold and violet, leaving some areas of white paper. Soften some of the edges with a damp 1-inch (25mm) bristle brush and leave others jagged and varied. Bring the same colors into the foreground of the painting and again soften some of the edges. Let dry.

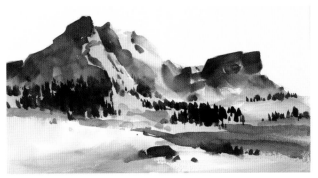

2 Divide up the Mountain Surfaces

Add a little blue to the rock mix and paint the shadow sides of the mountains with a ½-inch (13mm) flat brush, softening some edges at the bottom of the mountain range with the bristle brush.

Bring some of these darks to the foreground to add more interest to the painting. To create depth, paint the distant trees using the corner of the flat brush with a dark varied mix of green, yellow and blue. Be certain to make the trees that are the farthest away smaller, and gradually paint larger trees as they come forward in the painting.

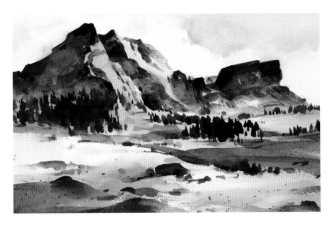

3 Develop Scale With Light and Shadow

Finish the painting with a no. 8 round brush and even darker rock mixes to suggest some of the rocky crags in the mountain faces, paying attention to the location of the light. Add a little more definition and texture to the foreground with the colors used in steps 1 and 2.

Paint in the sky with a wet mix of green, blue and green-blue, leaving areas of white paper to suggest clouds and softening some of the edges with a 1-inch (25mm) damp bristle brush.

Trees

In most landscapes trees are an essential element of the scene. They add a variety of interesting shapes and colors even if they are merely a backdrop for a foreground element of the composition. The colors and shapes of trees are diverse and often dramatic. The entire mood of a scene can be manipulated simply by changing the colors of the trees. Take the time to study individual types of trees, and pair that knowledge with these demonstrations for a great starting point for learning to paint trees.

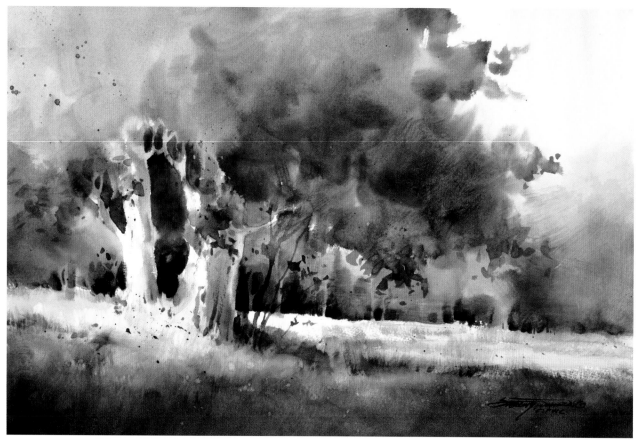

A Single Tree or Group of Trees Makes a Strong Center of Interest
In *Brothers*, I wanted to capture the strength of the two large trees in the meadow and accentuate the shade underneath the trees. Notice how the distant tree and shade under the foreground frame the area of light on the grassy area behind the large trees. This helps draw even more attention to the center of interest—the base of the large trees.

Brothers
Watercolor on 300-lb. (640gsm) cold-pressed Fabriano Artistico paper
15" × 22" (38cm × 56cm) • Private collection

EXERCISE
Evergreens

Evergreen trees add a familiar shape to a landscape, especially when they are grouped in a cluster of other types of trees. Their distinctive shapes and rich dark color act as an accent to lighter colored trees that are more baroque in shape. They also help break the monotony of the landscape and can sometimes create a sense of place. When painting high mountain scenes, the majority of the trees in the scene will be evergreen trees. Areas and mountains that are lower altitude will mostly include deciduous trees.

MATERIALS LIST

COLORS
Blue
Green
Reddish Brown

BRUSHES
1-inch (25mm) flat
no. 6 rigger

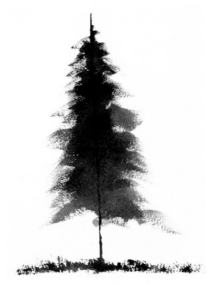

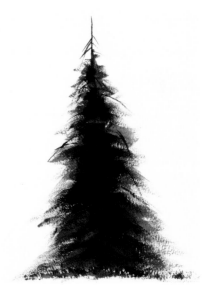

1 Establish the Height of the Tree
Establish the height of the tree that you want to paint by using the sharp edge of a 1-inch (25mm) flat and a wet mixture of green and reddish brown. Touch the edge of the brush to the paper in a straight line, stacking the shapes to the desired height. It's a good idea to suggest the ground at the base of the tree so you will have a reference point on how wide to make the tree.

2 Paint the Wispy Branches
Start at the top of the tree using only the corner of the 1-inch (25mm) flat and make quick downward brushstrokes beginning at the center of the tree. The quick brushstrokes help to create a dry-brush edge at the sides of the tree giving it a loose and wispy appearance. Repeat this procedure on both sides of the tree getting wider with the brushstrokes as you progress down the tree.

3 Add Volume to the Tree and Then Small Details
Add blue to the brownish-green mix that you've been using and start again at the top of the tree using the corner of the 1-inch (25mm) flat to suggest wispy branches in the center of the tree with quick brushstrokes. This will give the tree more dimension and add color excitement to the shape.

Suggest a few individual branches using a no. 6 rigger and a dark application of reddish brown. Additional height can be added to the top of the tree using the same color and brush if desired.

Summer Foliage

Trees with summer foliage are usually various shades of green. Typically the top of the tree or the part of the tree facing the light is a warmer and lighter green, while the areas of the tree near the bottom of the foliage will be cooler and more blue. Varying the colors in this manner gives the tree dimension and helps establish the light source in your painting. The same combination of warmer and cooler greens can also be used in the body of the tree to establish individual tufts of leaves. The outside edge of the foliage will help the viewer clearly determine that the shape is a tree. Try not to overwork the leaf shapes in the interior of the tree; let the outside edges tell the story.

MATERIALS LIST

COLORS
Blue
Green
Orange
Violet
Yellow

BRUSHES
1-inch (25mm) flat
no. 6 rigger
no. 8 round

1 Paint the Light Green Foliage to Suggest the Shape of the Tree

Begin foliage with a 1-inch (25mm) flat and a wet mixture of yellow and green. Hold the brush so the flat side delivers the paint rather than the tip of the brush. Move the brush in all directions applying very little pressure so that you get a broken edge that suggests leaves. Try not to make the tree too symmetrical or round, but rather give it some interesting shapes.

2 Paint the Darker Areas of Foliage

Add the darker shades of green to the areas of the tree not facing the light using the same brush and technique as in step 1. Add some blue to the mix of yellow and green. As you move toward the bottom of the tree where there is very little sunlight, add more blue to the mix of colors to suggest the darker areas in the shadows.

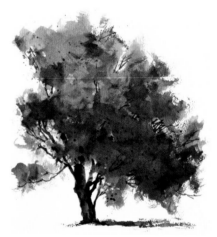

3 Paint the Tree Trunk and Add Final Tree Details

Paint the trunk with a no. 8 round and a wet mix of orange and violet. Add suggestions of blue and allow the colors to mix naturally on the wet paper.

Use a no. 6 rigger and the same colors as above to suggest the smaller branches. The branches should be smaller in size and more plentiful as you move up the tree. With a no. 8 round, suggest a few more dark areas on the trunk. Use the side of the rigger and a dark mix of green and orange to suggest a shadow on the ground underneath the tree and splatter a few individual leaves in the foliage.

Autumn Foliage

The same considerations of edge quality and definition of summer foliage apply to autumn trees. The outside edge tells the story, so it is unnecessary to create much detail in the interior of the tree. Generally, the leaves at the top of the tree will be lighter and brighter in value than those farther down the tree. Place a cast shadow on the ground beneath the tree to indicate the light source and anchor the tree to the ground.

MATERIALS LIST

COLORS
Blue
Magenta
Orange
Violet
Yellow

BRUSHES
1-inch (25mm) flat
no. 6 rigger
no. 8 round

1 Establish the Basic Shape of the Trees
Use a 1-inch (25mm) flat and a wet application of yellow to suggest the basic shape of the trees. To create leafy shapes, barely touch the flat side of the brush to the paper as you move it in all directions. While these shapes are still wet, use the same brush technique to introduce a wet mix of orange in some of the shapes. The two colors will blend by themselves on the wet paper.

2 Add Some Magenta and Violet to Suggest Darker Leaves
Suggest darker leaves that are not facing the light by using the same brush and technique as in step 1. Begin by adding some magenta followed by some violet at the bottom of the trees and on the side away from the light source. The darker shapes on the bottom of the trees add an element of weight to the shapes.

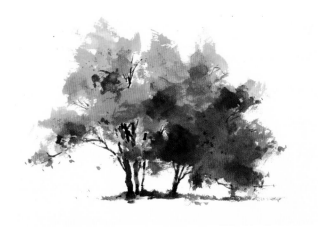

3 Paint the Trunks of the Trees
Paint the trunks of the trees with a no. 8 round and a wet mix of violet and orange. Skip some of the areas of foliage to suggest that the trunks are behind the leaves. While the shapes are still wet, add a few touches of blue to give the trunks and darker leaves a more textured look. Use a no. 6 rigger and the trunk mixture to suggest a shadow and grass on the ground. This helps to anchor the trees to the ground and reinforces the light source.

Paint the smaller branches with the no. 6 rigger and the same colors used to paint the trunks of the trees. Use the same brush and wet mixes of orange, magenta and violet to suggest individual leaves at the edges of the trees or falling to the ground. Add a few areas of splatter to the interior of the trees.

Bare Trees

Bare trees suggest winter and that the leaves have fallen. Winter scenes are often painted with more grays and neutral colors than spring, summer or fall scenes. The skeletal structure of the tree is more visible and should be painted with more definition than a tree with foliage. A good rule for bare branches is to extend them at about a 30 degree angle from the trunk or branch from which they originated. Taper the branches from thick to thin as they extend upward or outward and allow some to overlap. It is not necessary to paint every branch, but paint enough to give the tree some body and definition to help the viewer properly interpret the shapes as trees.

MATERIALS LIST

COLORS
Blue
Gold
Orange
Reddish Brown
Violet

BRUSHES
1-inch (25mm) stiff bristle
no. 6 rigger
no. 8 round

1 Establish the Basic Shapes
Render the basic shapes using a no. 8 round and varied mixes of blue, violet, gold and orange. To give the shapes more color and accentuate the rough textures of the bark, alternate the colors as you paint the shapes. While the shapes are still wet, add individual touches of the four colors and allow them to mix naturally on the wet paper. Use a no. 6 rigger and a mix of gold and blue to loosely suggest some grass at the bottom of the trees to anchor them into the ground.

2 Paint the Crown of Tiny Branches
Use a 1-inch (25mm) stiff bristle and a semi-wet mix of reddish brown and violet to paint the crown of tiny branches at the tops of the trees. Remove any excess water in the brush after mixing the colors. Starting at the top make quick downward strokes to create a dry-brush shape that will begin to resemble thousands of tiny twigs. Create the shapes in an arc formation to add more shape and strength to the trees.

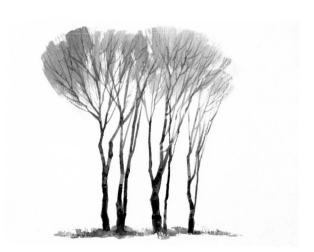

3 Add More Branches
Use the no. 6 rigger and a wet mix of blue, violet and orange to paint additional small branches that taper off at the top of the crest of tiny branches. This will give the trees a fuller look and add support to the thousands of tiny branches.

Use the rigger and variations of the above mixture to suggest a few areas of dark texture on the trunks of the trees. This will give the impression of rough bark and add drama to the shapes. With the mixture, add a small amount of splatter to the crest of small branches. Be sure to cover the sky and any other areas that you do not want to splatter.

Flowering Trees

Flowering trees are a bit of a challenge because you must paint the tree and suggest the flowers. In an effort to paint loose and fresh, the flowers on the tree should merely indicate and suggest flowers. Too much flower detail will make other elements of the tree appear underworked. The easiest way to suggest flowers is to mask them out beforehand. Then vary colors within the tree and use the outside edge of the overall tree to define the shape and leafy texture of the tree.

MATERIALS LIST

COLORS
Blue
Green
Orange
Reddish Brown
Violet
Yellow

BRUSHES
1-inch (25mm) flat
no. 4 and no. 8 rounds
no. 6 rigger

OTHER
Masking fluid

1 Mask the Shapes of the Flowers
Draw the shape of the tree on watercolor paper. Use a no. 6 rigger and masking fluid to mask the shapes of the flowers. Wait for the masking fluid to dry thoroughly before applying paint.

2 Paint the Main Body of the Tree
Use a 1-inch (25mm) flat to apply a wet mix of yellow and green to suggest the leafy shapes of the tree. Hold the brush with the flat side to the paper, and push and pull in all directions applying very light pressure. The result will be a broken and leafy edge. While the shape is still wet, repeat the process with a darker mix of yellow and blue to suggest the darker areas of the tree that are away from the light. Dry the paper thoroughly and remove the masking fluid.

3 Paint the Branches and Trunk, and Color the Flowers
Use a no. 8 round and varied mixes of orange, blue and violet to paint the trunk of the tree. While the shape is still wet, introduce a dark mix of orange and violet in a few spots and allow the colors to blend naturally on the wet paper. Use the same colors and a no. 6 rigger to suggest a few branches higher in the tree. Paint some darker leaves with a no. 4 round and a wet mix of blue and green around the white flower shapes and at the bottom of the tree. Use a rigger and a wet mix of green and reddish brown to suggest the grassy area underneath the tree.

Add some color to the flowers with a no. 4 round and a reddish brown hue. Make quick strokes of color on the white shapes of the flowers and do not feel compelled to color in the entire shape. The unpainted white areas add an element of cleanliness and sparkle to the flowers. Try not to overwork, or the green may blend with the pinkish hues and turn slightly gray.

Buildings

Buildings are always popular subjects in a landscape because they add the human element.

Any time you paint something architectural, you need to be aware of the light source. The shadows play an important role in the painting and help give the structure dimension. Without them everything would look flat. Even in paintings where there is not a well-defined light source, such as a snow scene with falling snow or scenes with stormy skies, it's still necessary to manipulate the values on the surfaces to establish a three-dimensional appearance. Minor changes in values from one shape to the other can often speak volumes.

Another important consideration when painting buildings has to do with the edge quality. Hard edges have strength and give the structure rigidity. Soft edges, however, let the eye move through the painting and give a painting a unified look where all the shapes work together to achieve an end result. With this in mind, it's a good rule of thumb to deliberately soften some of the edges to allow the eye to move about, particularly at the base of the structure where it comes in contact with the ground. A gradual transition from the ground to the shape of the structure looks much more natural and inviting than a hard line separating the two shapes. This is an often-overlooked concept that can make a big difference in your painting.

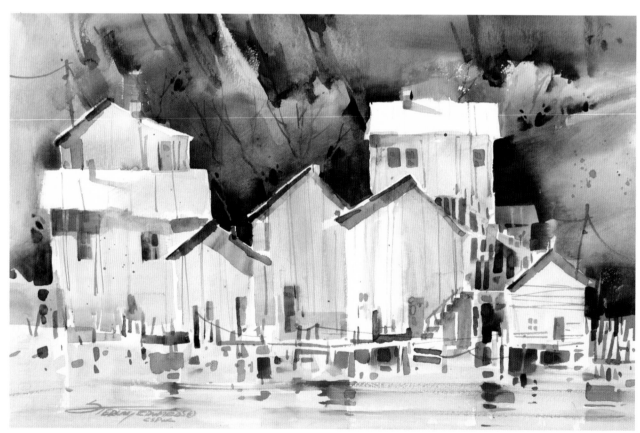

Cast Shadows Give Buildings a Three-Dimensional Feel
This depiction of a harbor in The Battery, a neighborhood in St. John's, Newfoundland, illustrates the importance of adding a few cast shadows to lend the buildings an element of dimension. Even though just the front side of each building is shown, the cast shadows underneath the eaves of the buildings help create a three-dimensional appearance. The hard edges of the tops of the buildings give the structures strength, while the softer edges of their bottoms help the eye easily move from shape to shape.

Noon on The Battery
Watercolor on 300-lb. (640gsm) Fabriano Artistico paper
15" × 22" (38cm × 56cm) • Private collection

Adobe

Adobe dwellings are often composed of stacked and interlocking shapes that are ideal for creating a painting with lots of movement and angles. The primitive and simple design of the buildings allows for the opportunity to exaggerate shapes and play with color and texture in ways that may not be accepted in other types of dwellings. Crooked doorways, handmade mud bricks, rough-hewn wood posts and crumbling mud walls add to the intrigue of these beautiful and historic structures.

MATERIALS LIST

COLORS
Blue
Dark Orange
Gold
Gray
Green
Green-blue
Light Orange
Reddish Brown
Violet

BRUSHES
½- and 1-inch (13mm and 25mm) flats
1-inch (25mm) stiff bristle
no. 8 round

1 Lay an Adobe Basecoat
Apply varied light washes of gold, orange and gray to the buildings, being careful to leave some white paper where the sun will be hitting the buildings. Paint around the upright post as a negative shape. Let dry.

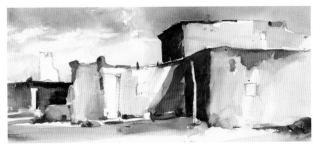

2 Add Dimension With Shadows
Paint the shadow sides using a flat brush with varied mixes of light and dark oranges and gray. Use a round brush and a wet mix of light orange and gray to add some texture to the side of the large wall to the right. Use a barely damp bristle brush to soften some of the edges before they dry.

3 Add Final Details
Use a mix of dark orange and gray to paint the wood posts that protrude from the buildings. Use a lighter mix of the same colors to suggest some cast shadows diagonally down the walls.

Paint the upright post with a wet mix of blue and reddish brown using your round brush.

Use a very dark mix of green, violet and reddish brown to paint the windows and distant doors. Paint the large door with a round brush and a wet mix of green-blue and gold.

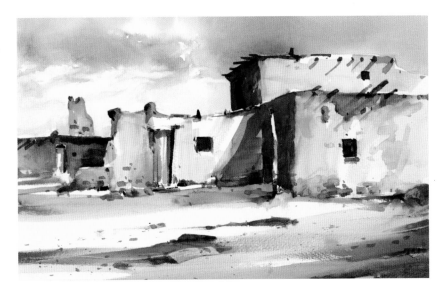

Old and Weathered

The oxidized, sun-bleached wood and rusty components of old, weathered buildings add wonderful colors, textures and shapes to your landscape paintings. It's not unusual for artists to exaggerate the overgrowth and sagging roofline in an old building just to give it more character.

MATERIALS LIST

COLORS
Blue
Gold
Gray
Green
Magenta
Orange
Reddish Brown

BRUSHES
½-, 1- and 2-inch (13mm, 25mm and 51mm) flats
no. 6 and no. 8 riggers

1 Establish the Building
Draw a barn focusing on large overlapping shapes and add interest to the top of the shapes by varying the heights.

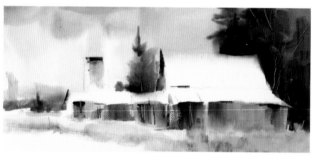

2 Paint the Building's Basecoat
Use a 1-inch (25mm) flat brush and varied mixes of magenta, gold and gray to paint the sides of the barn and silo. Suggest a few boards by scraping into the paint with the end of your brush. Leave the roof of the buildings as the white of the paper. Let dry.

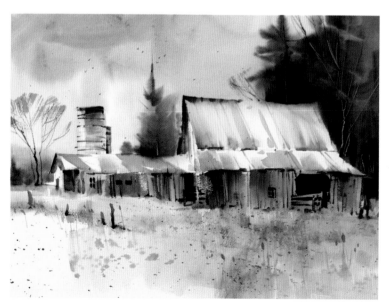

3 Develop the Building
Paint the roof with a wet and varied mix of orange, reddish brown and blue and a clean flat brush. Be careful to preserve some of the soft edges that resulted from working on the wet paper in step 2.

Paint the area inside of the barn using your flat and round brushes with a very dark mix of reddish brown, green and gray. As you paint, create negative shapes to add interest to the area. Use a round brush and the same dark mix to suggest some windows and boards.

Use a 1-inch (25mm) flat brush and a wet mix of blue and gray to paint some darker color on the side of the silo. Use the same brush and color to paint a cast shadow across the roof of the smaller building.

Traditional

Houses come in every size, shape and color you can imagine. Keep a reference file of house photographs to use when you want to add a little life to your landscapes. Adding simple features like a porch, chimney or dormer to your house helps break up the rooflines and is more entertaining to the eye than a relatively square building. Another popular way to add dimension to a house is to show two sides of the house rather than a direct view of its front. Even a slight juxtaposition of the house in the painting adds a great deal of depth and offers an even greater opportunity to accentuate the shadows.

MATERIALS LIST

COLORS
Blue
Gray
Green
Orange
Reddish Brown
Violet

BRUSHES
½-, 1- and 2-inch (13mm, 25mm and 51mm) flats
no. 6 rigger

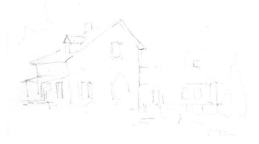

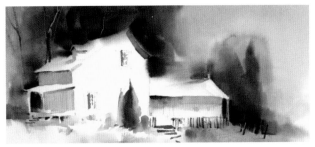

1 Establish the Building
Draw a simple sketch that shows two sides of the house and look for ways to make the outside edges more entertaining by adding chimneys or other architectural features that you would often find on a house. Include a few landscape features such as bushes or trees to help anchor the house to the landscape.

2 Give the Building Dimension and Depth
This white clapboard house is in direct sun, so we'll leave it the white of the paper and build its form and show depth by adding shadows and small details. It won't take much to make this shape recognizable as a house.

Use a no. 6 rigger and dark mixes of gray and reddish brown to suggest details such as the porch railing, steps and fence posts.

Paint the shadows on the building using 1-inch (25mm) flat brush with a wet mix of gray and blue. Paint the suggestion of windows using the same colors and a rigger brush.

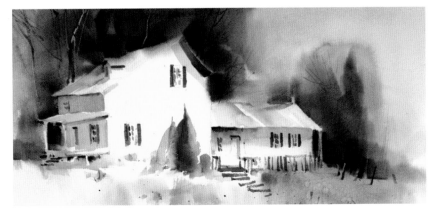

3 Add the Final Details
Use a ½-inch (13mm) flat brush and a dark green mix to paint the shutters on the windows. Add color to the roof with an orange and violet mix. Notice how keeping the shapes loose and concentrating on values and overlapping shapes create a sense of depth.

EXERCISE
Brick

Brick buildings pose a little more challenge depending upon the amount of detail you wish to show in the painting. If you have a photorealistic style, you will spend days and days painting every brick. However, it's not the bricks that make the painting interesting, it's the building. The bricks are just an architectural element that adds to the interpretation of the shape. Placing random bricks in a pleasing pattern is usually all that is necessary.

MATERIALS LIST

COLORS
Blue
Magenta
Orange
Reddish Brown
Violet

BRUSHES
½- and 1-inch (13mm and 25mm) flats
no. 6 rigger

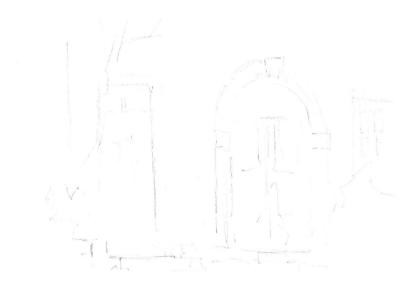

1 Establish the Structure
Draw a simple scene of a brick doorway.

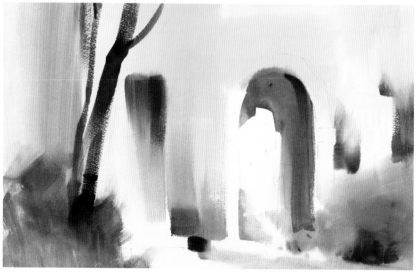

2 Add Initial Layers to the Building
Wet the entire piece of paper and use a 1-inch (25mm) flat brush to paint a very light mix of orange, magenta and reddish brown on the building. Paint around the areas inside the doorways where there will be light.

Add shadows inside the doors and windows with a flat brush and a dark mix of orange, violet and blue.

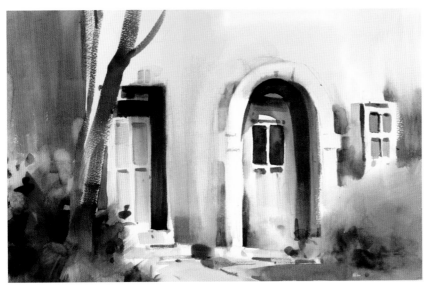

3 Develop the Light and Shadow

Give shape to the building by painting a shadow on the far left side with a 1-inch (25mm) flat brush and a dark mix of orange, violet and blue. Use this same mix to further deepen shadows in the doors and window areas.

Use a flat brush and wet mixes of magenta and violet to suggest the raised panels on the doors.

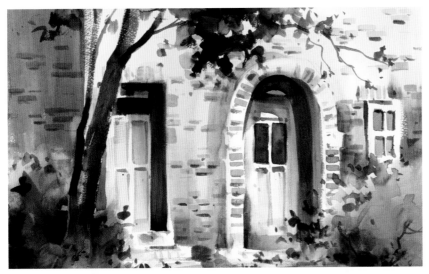

4 Add Defining Details

Use a ½-inch (13mm) flat brush and a mix of magenta, orange and violet to paint some of the bricks. When dry, use a no. 6 rigger and a darker mix of the same colors to suggest a shadow underneath the bricks. Use the rigger brush and a mix of blue and magenta to suggest small shadows on the raised wood panels of the doors.

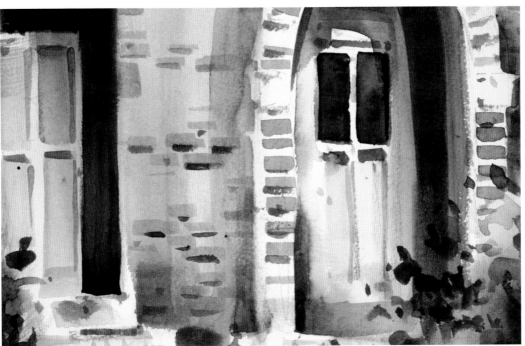

Add Shadows to Create Dimension

Adding a small shadow underneath the bricks helps give them dimension. Even though you didn't paint each brick, there is little doubt this is a brick building. By merely suggesting the bricks you can keep the painting loose.

Painting Water

Paintings with water are some of the most appealing of all watercolors because of the beautiful, reflective qualities of still water or the movement and energy that can be suggested with moving water.

One of the main points of consideration when painting a scene with water is to remember the water is a shape, nothing more and nothing less. As with all shapes, whether a positive shape or a negative shape, it needs to coincide with the other shapes in the painting to maintain cohesiveness and contribute to the visual entertainment of the finished painting. Therefore, the outside edges that define the shape of the water are just as important a design element as the shape of a tree or a building.

The main body of water in a painting of still water is always going to be level with the bottom edge of the painting. Therefore, it's important to keep the horizon line level. Moving water, such as waterfalls or splashing waves, is an excellent way to energize a painting with expressive energy and brushstrokes. Other variations that make water an interesting addition to a painting are the light conditions present at the time, the clarity of the water and the angle from which the water is viewed. There is no better teacher than observation, especially for the visual artist.

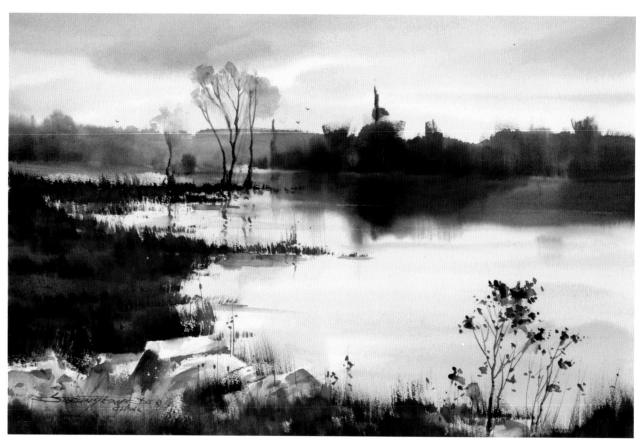

Create Reflections and Ripples to Determine Water Movement
As you plan your painting, determine how much movement there will be in the water so that the reflections will be read as they are supposed to. Water that is perfectly still will generally display a mirror image of the shapes above the water. Water that has a little movement will also display reflections, but these will be distorted by the ripples. Water that is moving quickly will often reflect color from above but will not display specific shapes.

Nogie's Creek
Watercolor on 300-lb. (640gsm) cold-pressed Fabriano paper
15" × 22" (38cm × 56cm) • Private collection

EXERCISE
Still Water

Watercolor is perfectly suited to painting still water. The manner in which wet colors flow on wet paper allows watercolor artists to create beautiful suggestions of glassy water with reflected shapes. This is particularly effective when using transparent watercolors. The white of the paper shows through the thin washes of color to create a clean impression of standing water. Still water is best rendered with larger brushes and fewer brushstrokes, especially during the first few washes. Use smaller brushes to depict reflections and details.

1 Do a Simple Sketch
Draw a horizon line and a few suggested shapes of trees on a piece of watercolor paper. Keep the horizon line either above or below the center of the paper.

2 Paint the Water Below the Horizon
Wet the paper from the horizon line to the bottom of the paper. Using a 1½-inch (38mm) stiff bristle, begin at the bottom of the paper and paint a wet wash of blue allowing the paint to become lighter as you approach the horizon. While the paper is still wet, use a 1-inch (25mm) flat to suggest the reflections of trees on the distant shoreline with a dry and varied mixture of green and reddish brown. Place the flat edge of the brush at the shoreline and make downward brushstrokes. When you have painted the reflections, dry the paper thoroughly.

3 Add Movement to the Water
On dry paper use the 1-inch (25mm) flat and a wet and slightly dark mix of blue to paint a few suggestions of movement on the water in the foreground. Allow the shapes to become smaller and lighter as you move farther up into the painting until they are no longer seen. Use a clean and barely damp 1-inch (25mm) flat brush to scrub and lift a few suggestions of shimmer on the water near the horizon. After each shape is scrubbed, use a piece of tissue paper to gently blot the moistened color.

Finish the painting by wetting the area above the horizon with clean water and applying a wet wash of blue beginning at the top and working toward the horizon. While the sky is still wet, use the 1-inch (25mm) flat and the varied mix of green and reddish brown to suggest the shapes of the trees. Leave a very thin area of unpainted white paper between the water and the trees to suggest a shoreline.

Choppy Water

Choppy water is best suggested as a series of peaks and valleys. Keeping the peaks lighter in value and the valleys darker in value creates the greatest illusion of depth and movement.

MATERIALS LIST

COLORS
Blue
Green-blue
Light Orange
Violet

BRUSHES
1- and 2-inch (25mm and 51mm) flat
no. 8 round

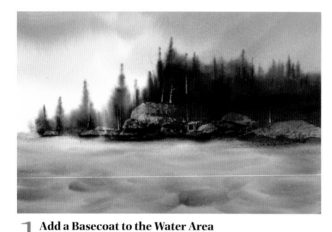

1 Add a Basecoat to the Water Area
Wet the entire piece of paper, wait a few moments and wet it again. Establish the horizon line, and while the paper is still wet, use a 2-inch (50mm) flat brush to paint the water with a mix of green-blue and violet. Use thicker mixes of the two colors here and there to give the water some rocky movement. Let dry.

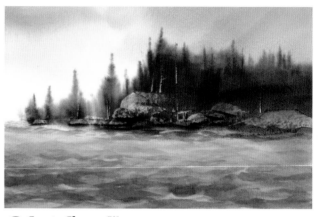

2 Create Choppy Waves
Use a 1-inch (25mm) flat brush and darker mixes of the green-blue and violet to paint more of the dark valleys between the waves. As you approach the distant shore, make the shapes smaller. At the base of the shoreline, use a flat brush and a dark mix of violet, light orange and blue to suggest some reflected color of the shoreline in the water.

3 Add Depth and Movement
Use a no. 8 round brush and a wet and dark mix of violet and green-blue to make dark, rocking shapes in the water. As you move from the bottom of the painting to the top, make the shapes smaller and lighter in value.

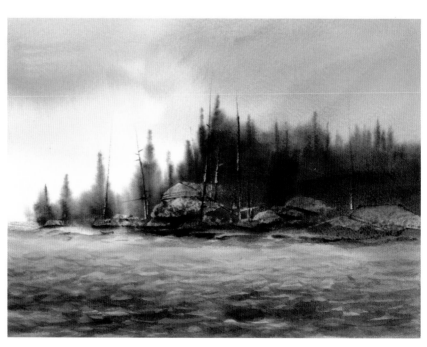

Moving Water

You can keep moving water from appearing flat by adding highlights and shadows, and by remembering to give the water some reflected color.

When painting moving water, pay particular attention to the outside edges of the water shape. This is especially true when painting waterfalls and rapids. The falling or choppy water creates a churning and splashing edge that is often left as white unpainted paper. When painting waterfalls or rapids, try using a rough watercolor paper. The rough surface will allow you to create nice, drybrush edges by moving the brush quickly over the paper.

MATERIALS LIST

COLORS
Blue
Gray
Green
Light Orange
Reddish Brown
Violet

BRUSHES
1- and 2-inch (25mm and 51mm) flat
1-inch (25mm) stiff bristle
no. 8 round

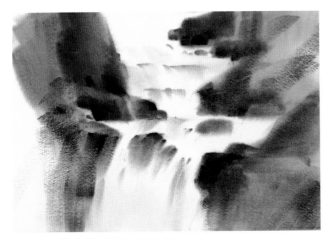

1 Establish the Water's Path

Wet the entire piece of paper thoroughly, wait approximately three or four minutes and wet again. Use 2-inch (50mm) flat brush and wet washes of blue, violet and gray to suggest some of the color of the water. Leave areas of white paper that will later be accentuated with some dry-brush texture.

While the paper is still wet, use the same brush and varied mixes of light orange, reddish brown and gray to block in the shapes of the rocks. Since the paper is wet, you will get soft edges where the shapes of the rocks and water meet. This will help establish the effect of moving water.

Use a damp 1-inch (25mm) bristle brush to blend and soften edges as you paint the rocks. As the paper begins to dry, use darker mixes of the rock color to suggest individual rocks. Let dry.

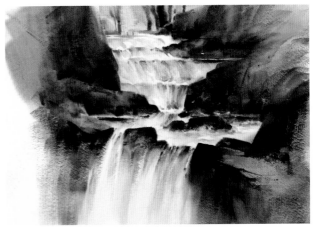

2 Intensify the Light and Shadow to Portray Movement

Continue working on the rocks with a ½-inch (13mm) flat brush and darker mixes of the rock colors that you previously used, but now incorporate some blue to accentuate and darken the areas between the rocks. Sharpen the edges on the rocks that are in front of the water and soften some of the edges that meet the water.

Use a no. 8 round brush and wet mixes of green, gray and reddish brown to define the various levels of the cascading water. Soften an occasional edge. It is important to have a nice balance of soft edges, dry-brush edges and hard edges.

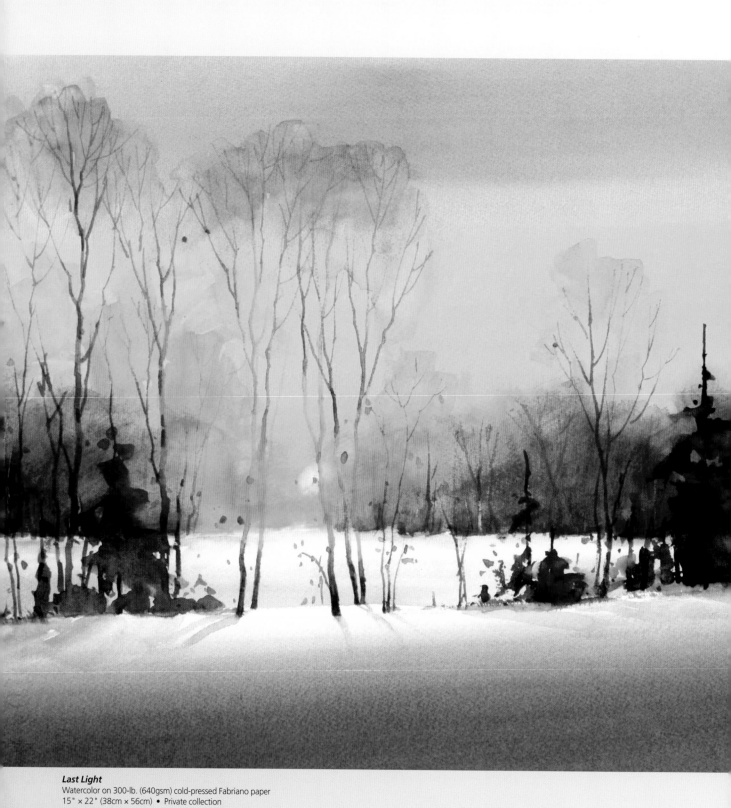

Last Light
Watercolor on 300-lb. (640gsm) cold-pressed Fabriano paper
15" × 22" (38cm × 56cm) • Private collection

6

Painting Luminous Landscapes Step by Step

*A*ll of the demonstrations in this chapter have been painted with transparent watercolors using my four-step process. Transparent watercolors are great for achieving a luminous glow in your work; however, the techniques and principles applied in these demonstrations work equally well with opaque and semiopaque watercolors, and even with oils and acrylics.

When you complete a painting using the four-step process explained in detail over the next several pages, you will achieve a variety of strong midvalues that act as the glue holding the shapes together. Your darks will be richer, giving the painting drama and strength. You will have an area of clean, unpainted white paper, giving the painting light and sparkle. And most importantly, you'll have a strong center of interest to lead the viewer's eye. If you need a refresher before diving into the following demonstrations, revisit the exercises in chapter 5 on the basics of landscape elements.

The Four-Step Process

I discovered through teaching watercolor that many of my students were unsure of how to begin a painting. Over the years the same questions kept popping up—*Should I paint the sky first? What would you do to start this painting?* There are no rules about what must be painted first; in reality, each painting is unique and requires its own approach. When I set out to develop the four-step process, I wanted a system that was easy to follow and placed emphasis on how to begin a painting, as well as one that added an element of structure to the painting experience. Focusing on values was the way to accomplish these goals.

The key to creating depth and luminosity in your watercolors is developing your mid and dark values in the beginning stages of the painting rather than the end. You can have beautiful colors, intriguing shapes and interesting textures, but values are what make the painting inspiring. Another important part of my four-step process is to preserve a bit of the white paper as a way to plan sparkling highlights down the line.

Here are the stages that make up the four-step process:

Step 1: Block in shapes and midvalues while saving white paper. The white of the paper left will be the center of interest.

Step 2: Add the darkest darks to illuminate the midvalues and white paper.

Step 3: Glaze selectively over the white space that you do not wish to preserve.

Step 4: Add finishing details and refine.

I have taught the four-step process for a long time, and I still hear positive feedback from students who have achieved success with it. Many say it has changed the way they paint and that they are no longer as intimidated by watercolors as they used to be. I encourage you to refer to these next few pages as you work through the demonstrations later in this chapter.

MATERIALS LIST

PAPER
140-lb. (300gsm) cold-pressed watercolor paper

PAINTS
Avignon Orange
Cupric Green Deep
Golden Lake
Permanent Violet Blueish
Primary Blue-Cyan

BRUSHES
1- and 2-inch (25mm and 51mm) flats
1-inch (25mm) stiff bristle
no. 6 rigger
no. 8 round

OTHER
1-inch (25mm) masking tape
2B pencil
Mounting board
Tissue and paper towel blotter
Tissue
Two water containers

After you complete your preliminary sketch, begin painting the midvalues. The most important part of step 1 is to leave some white of the paper where the center of interest will be. Some midvalues will be lighter and some will be darker, but they will all fall near the midvalue range. The goal of step 1 is to establish the painting's colors and create the center of interest by preserving some white of the paper.

Draw the Largest Shapes
Draw a simple sketch of the tree and grass, and suggest the tops of the background trees. Focus mainly on the larger shapes. In this exercise the base of the large tree will be the center of interest.

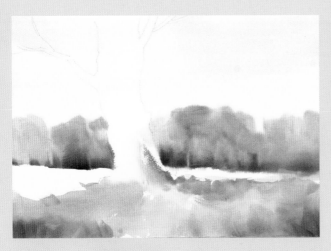

Begin the Midvalues While Saving Some White Paper
Wet the entire piece of paper with a 2-inch (51mm) flat brush. Use this brush to apply a light, wet wash of Primary Blue-Cyan starting at the top of the paper. Make long, overlapping horizontal strokes working downward. Since this is a light color, it's OK to paint over the trees. As you work downward, the paint in your brush should get thinner giving you a graded wash. While the paper is still wet, use a 1-inch (25mm) flat brush and drier combinations of Golden Lake, Permanent Violet Blueish, Cupric Green Deep and Avignon Orange to paint the background trees. Leave an area of white at the base of the trees to suggest a sunlit field and paint around the large tree. Darken the colors at the base of the background trees to help anchor them to the ground. If necessary, use a 1-inch (25mm) barely damp stiff bristle brush to softly blend some of the colors on the wet paper. Use the 1-inch (25mm) flat brush and varied combinations of Golden Lake and Avignon Orange to paint the foreground grass. Soften the grass shapes with the barely damp 1-inch (25mm) stiff bristle brush. Let the paper dry before continuing.

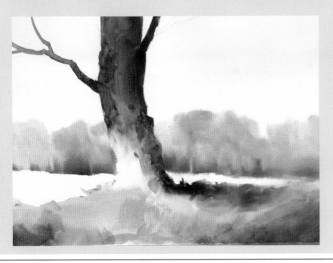

Continue Adding Midvalues
Paint the tree with a 1-inch (25mm) flat brush and a no. 8 round and a combination of Permanent Violet Blueish, Avignon Orange and Golden Lake. Add more color and darker midvalues to the grass with the 1-inch (25mm) flat brush and combinations of Golden Lake, Primary Blue-Cyan and Avignon Orange. Suggest a cast shadow on the grass with a little darker combination of the same color and soften some of the edges.

Step Two: Add the Darkest Values

When step 1 is dry, begin to apply the darkest darks. Like many beginning watercolor artists, I used to be timid with my dark tones. The darks are important because they illuminate the midvalues and white paper, especially with transparent watercolors. It's a big leap to overcome the fear of painting dark values, but when you do, you'll be amazed at the impact they make on the painting.

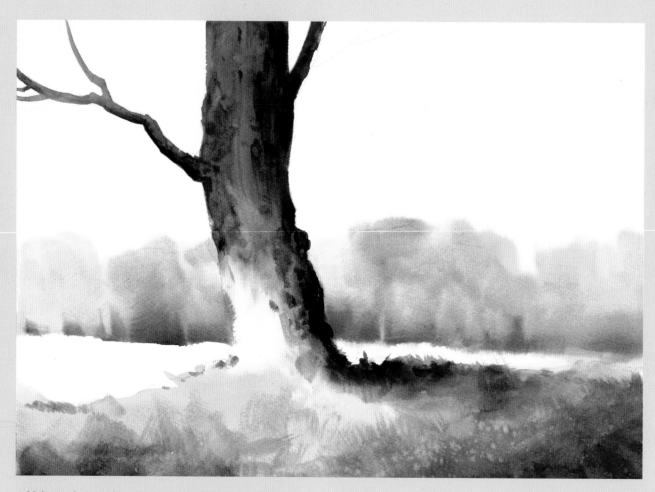

Add the Darkest Darks to Make the Background Brighter
Using a no. 8 round brush, apply a dark combination of Permanent Violet Blueish, Primary Blue-Cyan and Avignon Orange to the shadow side of the tree. As you move toward the center of the tree, use a barely damp 1-inch (25mm) stiff bristle brush to soften the edges. Use the same brushes and color combinations to darken the shadow on the grass at the base of the tree. With a 1-inch (25mm) flat brush, darken the grass along the bottom of the painting with a combination of Golden Lake, Primary Blue-Cyan and Permanent Violet Blueish. As the extra color in the grass begins to dry, use a no. 6 rigger brush to splatter clear water on the grass. This technique will produce small backruns that resemble weeds. With the darkest darks in place it's easy to see the dramatic difference in the painting. The background trees now appear brighter and more colorful, while the unpainted white paper looks cleaner and brighter.

Step 3, the easiest step, begins after you've got your darks in place. Begin by studying the area of the center of interest that you've left as the white of the paper. Selectively add thin glazes of color to any of the white areas that you do not want to keep. The thin transparent glazes allow the white of the paper to shine through the colors giving them a clean and luminous quality. It's important to leave some of the white while toning down the unwanted white to help draw the viewer's eye. Placing some rich dark tones adjacent to the white paper is a good way to make the center of interest stronger and more dramatic.

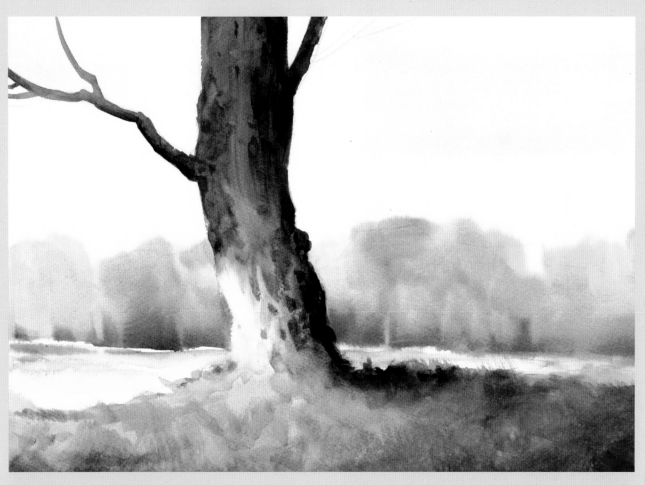

Selectively Glaze Some of the White Paper

Use a 1-inch (25mm) flat brush and a wet mix of Golden Lake to add some color to the field behind the big tree. As you paint the field, be sure to leave some white paper at the base of the trees to suggest sunlight hitting the top of the grass. While this color is still wet, use the same brush to add a small touch of Primary Blue-Cyan and Avignon Orange to the Golden Lake. Use a 1-inch (25mm) barely damp stiff bristle brush to soften an occasional edge. Add a thin glaze of Golden Lake to the foreground grass using the 1-inch (25mm) flat brush and softly blend the color as you approach the base of the large tree. This will allow the color of the grass to blend with the base of the tree so the two shapes flow into each other, creating a soft transition. Leave most of the base of the tree as unpainted paper and use a no. 8 round brush to add a few suggestions of bark with a combination of Permanent Violet Blueish and Golden Lake.

Notice how rich the colors in the painting appear because of the small areas of white paper. When glazing color in the third step, do so sparingly so you don't get carried away and lose the unpainted paper that you have carefully preserved up to this point.

This is the most fun of the four steps because you can get out the small brushes and add the final details and textures that give the painting its completed look. It's also a good opportunity to evaluate the shapes and dark values and refine them if necessary.

By completing most of your paintings with larger brushes, you will be able to create faster and looser shapes. In my own paintings, I usually have a 90:10 ratio of large to small brush usage.

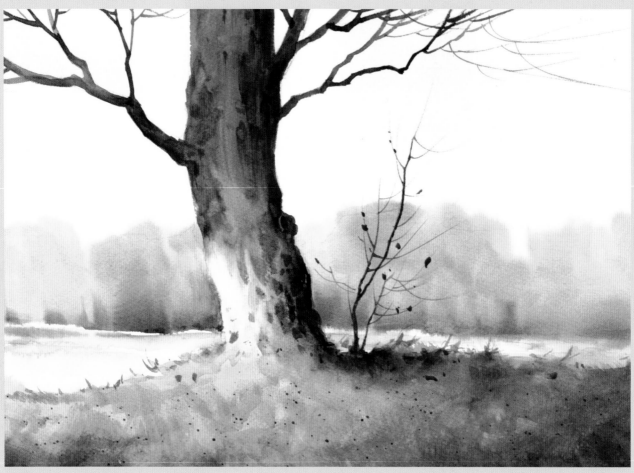

Add the Smaller Branches and a Second Tree
Use a no. 6 rigger and a dark combination of Primary Blue-Cyan, Permanent Violet Blueish and Avignon Orange to paint the smaller branches and the second tree. To add more texture to the foreground grass, use the same dark combination of colors and the rigger to splatter some small drops in the grass to resemble weeds. Be sure to cover any part of the painting you do not want to splatter. When the small tree has dried, use the rigger and a dark combination of Golden Lake and Avignon Orange to add a few leaves to the smaller tree. This not only makes the scene more colorful, it also adds a nice dark value in front of the background trees. Finally, use the rigger and a mixture of Golden Lake, Primary Blue-Cyan and Permanent Violet Blueish to suggest a few individual blades of grass at the top of the knoll.

These close-ups illustrate the power of using dark, rich values next to whites and midvalues. A little bit of texture goes a long way in producing suggested shapes such as tree bark and grass. Practice this four-step exercise several times to help you gain confidence in placing your darks and preserving whites. The difference it will make in your paintings is quite extraordinary.

Base of the Tree, Right Side
The white paper in the background gives the darks more strength.

Base of Tree and Grass Texture
Allowing the tree and grass to become one shape makes the transition gradual and softer.

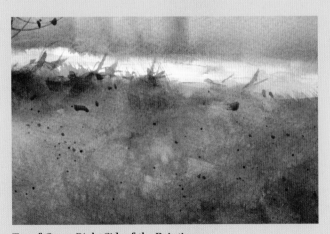

Top of Grass, Right Side of the Painting
The grass is composed mainly of color and splattered texture with just a small amount of definition at the edge.

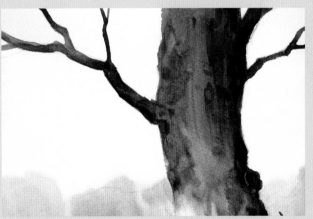

Tree Trunk and Branches
Charging one color into an existing wet color adds texture as well as color.

A Desert Tree Scene

This old tree in Monument Valley, Utah, has all of the elements of the process represented: rich, dark values; a variety of midvalues; and a focus point that sparkles with the white of the paper. It has strength and drama because of its sharp value shifts, but it also has a glowing luminosity thanks to transparent colors.

MATERIALS LIST

PAPER
300-lb. (640gsm) cold-pressed watercolor paper

PAINTS
Avignon Orange
Brown Stil de Grain
Golden Lake
Green Blue
Payne's Grey
Permanent Violet Blueish
Primary Blue-Cyan
Primary Red-Magenta

BRUSHES
1- and 2-inch (25mm and 51mm) flats
1-inch (25mm) stiff bristle
no. 3 rigger
no. 8 round

OTHER
1-inch (25mm) masking tape
2B pencil
Kneaded eraser
Mounting board
Tissue and paper towel blotter

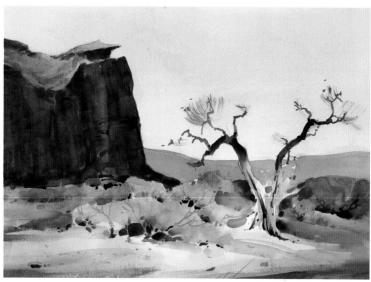

Value Study
Since I have a value study, I do not need the photograph to do this painting. This makes it easy to be more expressive and creative with colors rather than trying to replicate the colors in the photograph. As long as I keep the values the same as the value study, the painting should read well.

Sketch the Simple Shapes
Use a 2B pencil to make a light sketch on a piece of 300-lb. (640gsm) watercolor paper and mount the paper using 1-inch (25mm) masking tape.

Step One: Block In Shapes While Saving Whites

1 Place the Midtones and Create the Center of Interest

With the paper slightly tilted, wet the entire sheet of paper thoroughly. Use a wet mix of Golden Lake and a 2-inch (51mm) flat brush to paint the sky near the bottom of the horizon. While everything is still wet, start at the top of the sky and use the same brush to paint a wet wash of Primary Red-Magenta, working down the sky until it mixes with the Golden Lake. While the paper is still wet, use a 1-inch (25mm) flat brush and mixes of Green Blue and Golden Lake to suggest a few of the bushes in the foreground. Paint around the drawing of the tree trunk, leaving it white since that area will be the center of interest.

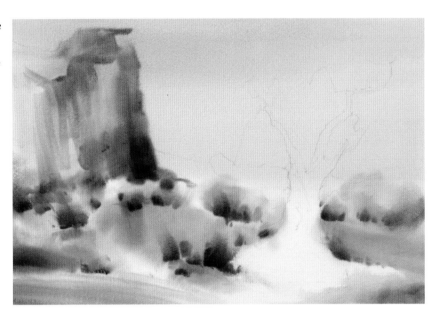

Using a drier mix of the Green Blue and Golden Lake, suggest a few areas of shadow underneath some of the bushes to give them more definition. As you apply color, use a barely damp 1-inch (25mm) stiff bristle to soften some of the edges. Finally use a drier mix of Brown Stil de Grain and Payne's Grey to suggest the distant butte and the sandy foreground. Soften some edges with the barely damp bristle brush. Dry the paper thoroughly.

2 Develop the Background Midvalues and Introduce Some Dark Values

Use a wet mix of Primary Blue-Cyan and Permanent Violet Blueish to paint the distant ridge. As you apply the color, use a barely damp bristle brush to soften some of the edges of the foreground bushes. Use a wet mix of Green Blue, Golden Lake and Primary Blue-Cyan to suggest the different levels of bushes. Again, use the damp bristle brush to soften some of the edges. Use a wet mix of Brown Stil de Grain and Permanent Violet Blueish to indicate more of the terrain and give the foreground a greater variety of values and textures. Using a wet mix of Payne's Grey, Golden Lake and Brown Stil de Grain, begin introducing darker midvalues to the foreground rocks and sand, then soften some of the edges.

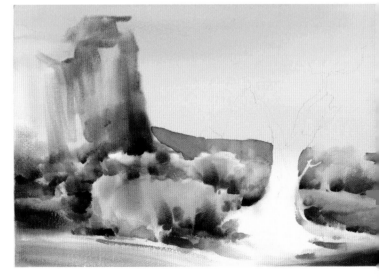

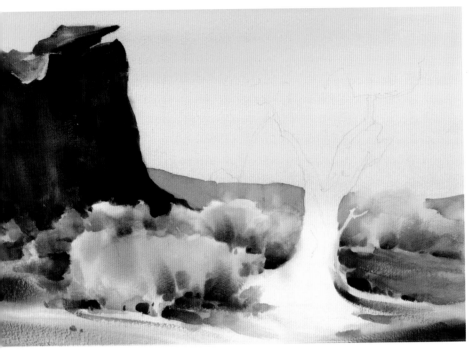

3 Add Darks to Make the Midvalues and Center of Interest Pop

Use a heavy, dark mix of Brown Stil de Grain, Avignon Orange and Payne's Grey to paint the large butte. Vary the applications of color as you paint so that it does not end up as just one color. Leave some of the midvalues at the top of the butte to suggest light and create more interest. At the base of the butte, use a barely damp bristle brush to soften a few of the edges at the tops of the bushes to give them a softer look. Use the same color mix to add a few darks under the foreground bushes and to the right of the tree. Notice how much brighter the midvalues and the white paper appear when the darks are added.

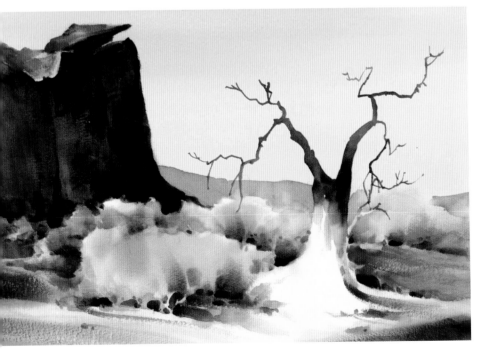

4 Paint the Center of Interest With Positive and Negative Shapes

Paint the tree with a wet and heavy mix of Avignon Orange, Primary Blue-Cyan and Brown Stil de Grain. Vary the colors as you apply them to make the shapes more interesting, and use a damp bristle brush to soften the edge where the tree comes down to the white negative shape. Use a no. 3 rigger brush to apply the small branches at the top. Next use a wet mix of Brown Stil de Grain and Avignon Orange to add darks to the bottom of the bushes. Use a no. 8 round brush and a rigger brush to suggest a few negative branches and stems in the bushes.

5 **Address the Remaining White Areas in the Center of Interest**
Use a wet mix of Golden Lake, Payne's Grey and Brown Stil de Grain to suggest a few cast shadows across the ground at the base and on the trunk of the tree. Make the shadows follow the contour of the subject that the shadow is cast upon. Use a damp bristle brush to soften some of the edges. Notice how the small area of white paper draws the eye to the center of interest.

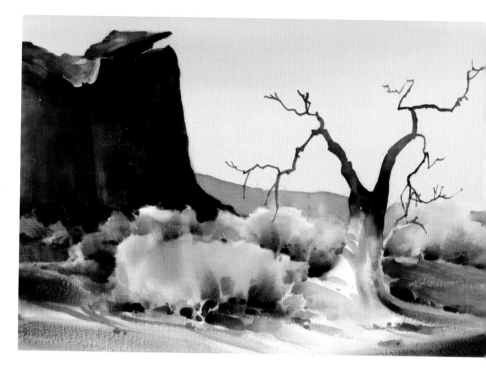

6 **Begin the Small Details**
To add detail to the painting use a 1-inch (25mm) stiff bristle brush that is barely damp and a relatively dry mix of Payne's Grey and Brown Stil de Grain. In as few brushstrokes as possible suggest the scrubby foliage on the tree. Use a wet mix of Golden Lake to apply a thin glaze of color over some of the left-side bushes to vary the color and make the side facing the light a little brighter. Use a wet mix of Green Blue to add color and shadow to the right sides of the bushes. Softly blend the unwanted edges with a slightly damp bristle brush and dry the paper.

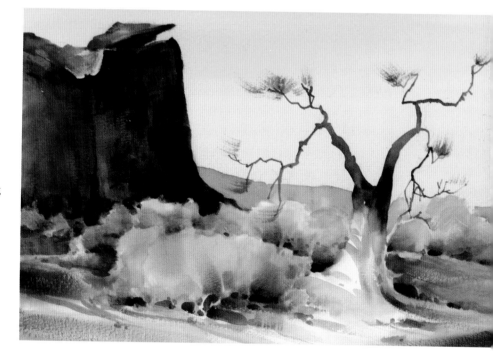

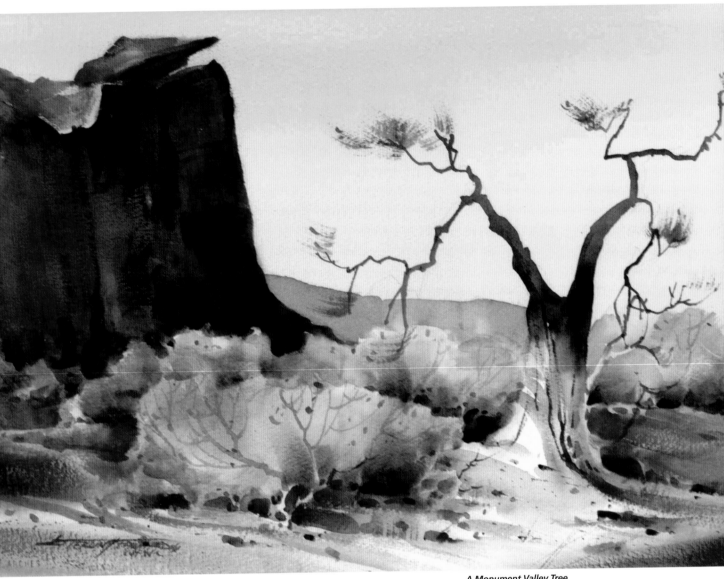

A Monument Valley Tree
Watercolor on 300-lb. (640gsm) cold-pressed Fabriano paper
15" × 22" (38cm × 56cm) • Private collection

7 Evaluate the Values and Add the Finishing Touches

Finish the painting using a rigger brush and a wet mix of Green Blue and Brown Stil de Grain to suggest a few small branches in the bushes. Use a small damp brush to blend the lighter, negative-shaped branches with the darker positive-shaped branches. Use a darker mix of Green Blue and Golden Lake to suggest a few individual leaves in the bushes. Use the rigger brush and a dark mix of Payne's Grey and Brown Stil de Grain to suggest the cracks in the old tree trunk. The same mix can be used to suggest a few rocks in the foreground.

Snow Scene

Snow scenes are always popular subjects with watercolor artists because the painting is half finished before you put a brushstroke on the paper. You can give your snow depth and dimension by suggesting shadows that conform to the terrain on which the snow is lying. These soft shadows create the illusion of movement on the surface of the snow. The colors of the shadows are important in designing your painting. Typically snow acts as a reflector in a subtle way and can change in appearance as the sky above it changes. On bright and sunny days snow has bluer shadows that reflect the blue sky, whereas on overcast or gray days the shadows are usually gray. Taking the time to study your subject and note the subtleties will be time well spent.

MATERIALS LIST

PAPER
300-lb. (640gsm) cold-pressed watercolor paper

PAINTS
Brown Stil de Grain
Golden Lake
Payne's Grey
Permanent Green Deep
Permanent Violet Blueish
Primary Blue-Cyan

BRUSHES
½- and 1-inch (13mm and 25mm) flats
1- and 1½-inch (25mm and 38mm) stiff bristles
no. 6 rigger
no. 8 round

OTHER
2B pencil
Kneaded eraser
Tissue

Reference Photo
This photograph shows beautiful, subtle shading between the ridges of snow and has soft gray cast shadows similar to the value and color of the overcast sky. Even though the sky is cloudy, there is enough diffused light in the sky to create some beautiful shadows.

Sketch the Simple Shapes

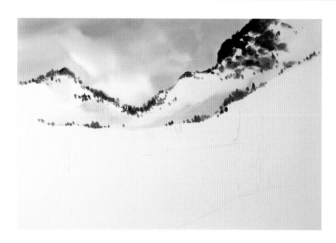

1 Paint the Sky and Begin the Mountain
Tilt the paper slightly toward you and wet the area of the sky while keeping the distant ridgetop dry. Use a 1-inch (25mm) flat and varied mixes of Payne's Grey, Permanent Violet Blueish and Brown Stil de Grain to paint the sky leaving some areas of the sky lighter to suggest filtered sunlight. While the sky is still wet, use the same colors mixed together into a gray to suggest some shadows in the ravine between the two ridges. Use a barely damp 1-inch (25mm) stiff bristle brush to soften the top edge of the shadow. Before the paper dries, use a no. 8 round brush and drier mixes of Golden Lake, Permanent Green Deep and Brown Stil de Grain to suggest small pine trees on the ridges. Paint the rock formations with a no. 8 round brush and darker mixes of Permanent Violet Blueish and Brown Stil de Grain. Let dry.

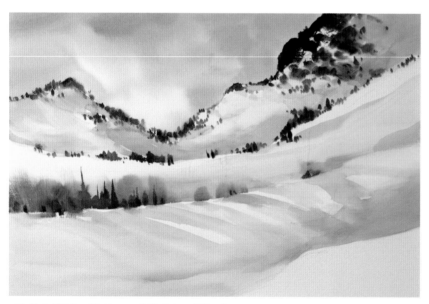

2 Establish a Pattern of Light and Shadow
Add more of the shadow gray to the upper ridge using a 1-inch (25mm) flat brush. Softly blend some of the edges with a barely damp 1-inch (25mm) stiff bristle brush. Use the same flat brush and colors to suggest the shadows between the lower two ridges while including some subtle cast shadows that roll down the ridge following the curve of the terrain. Again, use a barely damp 1-inch (25mm) stiff bristle brush to soften some of the edges. While the shadows are still wet, use a 1-inch (25mm) flat brush and a dry mix of Brown Stil de Grain and Permanent Violet Blueish to suggest the outcropping of aspen trees along the ridgetops. Allow the tops of the trees to soften on the wet paper. Use the 1-inch (25mm) flat brush and dry mixes of Permanent Green Deep and Brown Stil de Grain to include a few pine trees in the damp shapes.

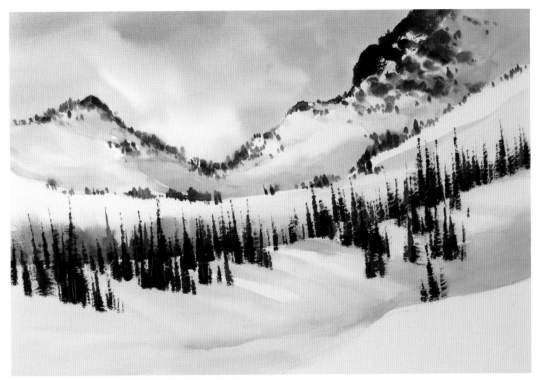

3 Paint the Evergreens

Use a 1½-inch (38mm) bristle brush and a relatively dry mix of Permanent Green Deep, Brown Stil de Grain and Primary Blue-Cyan to paint the dark pine trees. For best results load the brush with the dry color, place the corner of the brush at the base of the tree and gently press downward. It's a good idea to practice this technique on a separate piece of paper before attempting this on your painting. Vary the colors of the trees as you paint them and vary the size of the trees. While the trees are still wet, use a beveled brush handle or knife to scrape a few tree trunks just as the shapes are losing their shine. To add more depth to the painting, make some of the trees darker than others. The sharp edges of the larger trees are a nice contrast to the softer edges of the smaller distant trees that were rendered on wet paper.

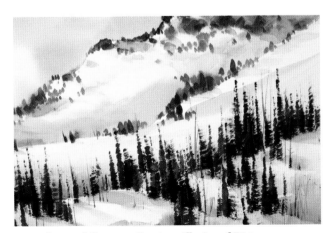

Vary Edges and Shapes to Create an Illusion of Distance
Darker shapes with crisp edges against a backdrop of soft shapes create the illusion of distance and atmosphere.

Discover the Effectiveness of a Bristle Brush
This close-up illustrates how effective a bristle brush is for creating evergreen trees.

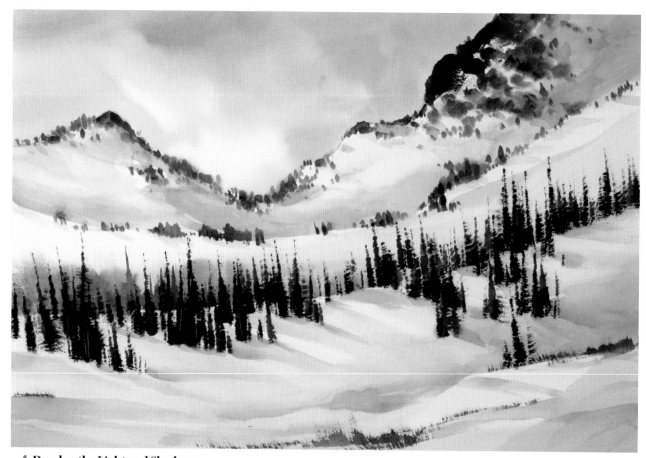

4 Develop the Light and Shadow
Add more of the shadows on the snow using a 1-inch (25mm) flat and the gray mix of Primary Blue-Cyan, Permanent Violet Blueish and Brown Stil de Grain. Suggest that the trees are nestled in the snow by painting a mix of the gray shadow color at the base of the trees and blending away the top edges with a barely damp 1-inch (25mm) bristle brush. Use the 1-inch (25mm) flat brush and the same gray mix to tone down the bottom edges of the painting while leaving some areas of white paper to suggest light on the snow. Use a 1½-inch (38mm) bristle brush and a dry mix of Golden Lake and Brown Stil de Grain to suggest grassy shapes in the foreground.

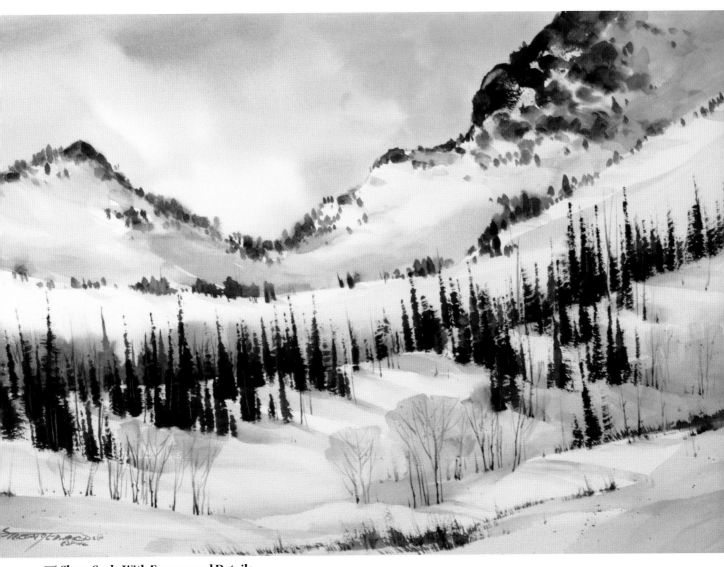

5 Show Scale With Foreground Details

Lift some of the color from the rocks at the top of the distant ridge by wetting small areas with a no. 8 round brush, waiting four or five seconds, and blotting with a piece of facial tissue. This will create the illusion of highlights and add more dimension to the rocks. Paint the tops of the aspen trees in the foreground with a wet, light mix of Golden Lake and Permanent Violet Blueish. While the shape is still wet, use a 1-inch (25mm) damp bristle brush to blend away the bottom edge. When the tree shapes are dry, use a no. 6 rigger brush and a dark mix of Brown Stil de Grain and Permanent Violet Blueish to paint the tree trunks and larger branches of the aspen trees, and some of the pine trees. Use the rigger brush and a mix of Brown Stil de Grain and Permanent Violet Blueish to add a little splatter to the aspen trees and in the foreground to suggest ground clutter.

Notice how overlapping shapes and diminishing the sizes of the trees as they recede into the distance adds depth to the painting.

A Salt Lake Moment
Watercolor on 300-lb. (640gsm) Fabriano Artistico paper
15" × 22" (38cm × 56cm) • Private collection

Waterfall

As with snow scenes most of the time, the white of the paper suggests the water as it is framed within a darker background. The darker the background, the whiter the waterfall will appear.

I like to use paper with a rougher surface texture when I paint waterfalls because I can rely on the roughness or *tooth* of the paper to suggest the falling water at the edges of the waterfall better than I can on smooth paper. This broken edge or *dry-brush effect* is best achieved by holding the brush almost parallel with the surface of the paper and making quick brushstrokes.

MATERIALS LIST

PAPER
300-lb. (640gsm) cold-pressed watercolor paper

PAINTS
Brown Stil de Grain
Golden Lake
Indian Yellow
Orange Lake
Permanent Green Deep
Permanent Violet Blueish
Primary Blue-Cyan

BRUSHES
½-, 1- and 2-inch (13mm, 25mm and 51mm) flats

1-inch (25mm) stiff bristles
no. 6 rigger
no. 8 round

OTHER
2B pencil
Kneaded eraser
Tissue

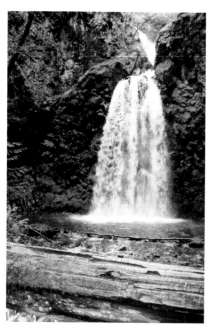

Reference Photo
This waterfall has a very pleasing shape and is surrounded by beautiful green mossy rocks. Even the fallen log at the bottom of the photograph adds an intriguing element of design to the scene.

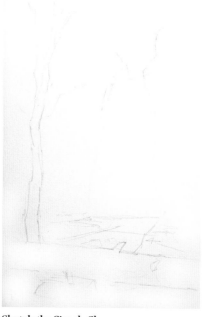

Sketch the Simple Shapes
To enhance the composition it will be necessary to move or add a few things. For example, the tree on the left of the photograph is barely visible. Moving it closer to the center will add a strong vertical shape that will complement the vertical of the waterfall. The foreground log needs a few branches to make the shape a little more interesting.

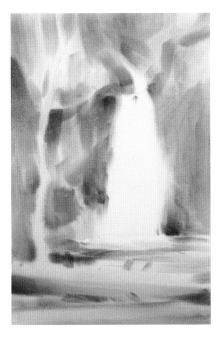

1 Add Initial Shapes With Negative Painting
Begin by slightly tilting the paper toward you and thoroughly wetting the paper. Use a 2-inch (51mm) flat and light mixes of Permanent Green Deep and Indian Yellow to suggest the location of the mossy rocks and foliage at the sides of the waterfall. Leave the areas that are to be water as white paper. Add some Brown Stil de Grain to the mix as you paint to suggest some of the rocks. This is also a good time to paint around the foreground tree as a negative shape. Paint the water at the bottom of the falls with a mix of Primary Blue-Cyan, Permanent Violet Blueish and Orange Lake. Use a barely damp 1-inch (25mm) stiff bristle to soften and blend some of the edges. Suggest the colors of the fallen log with varied mixes of Orange Lake and Permanent Violet Blueish. Let dry.

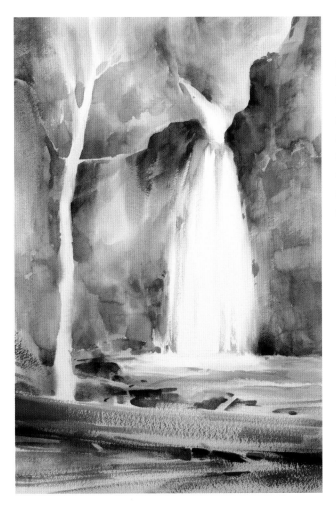

2 Add More Shapes
Continue blocking in the shapes on dry paper using a 1-inch (25mm) flat and varied midvalues of Indian Yellow and Brown Stil de Grain for the moss and foliage. Use a barely damp 1-inch (25mm) stiff bristle to lightly soften some of the edges. Use a mix of Permanent Violet Blueish, Orange Lake and Brown Stil de Grain to paint the rock formations and the foreground logs. Suggest movement in the falling water with a no. 8 round brush and a light mix of Primary Blue-Cyan, Permanent Violet Blueish and Brown Stil de Grain. Use a barely damp ½-inch (13mm) flat to soften some of the edges while they are still wet.

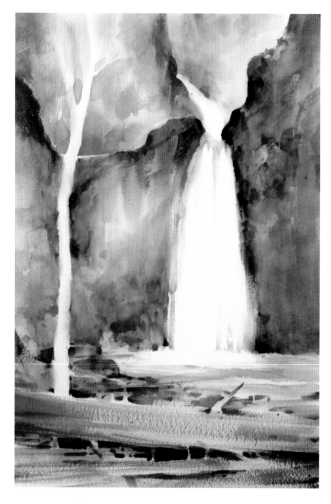

3 Add Foliage

Paint the foliage next to the falling water with a 1-inch (25mm) flat using dark and varied mixes of Indian Yellow, Brown Stil de Grain, Permanent Green Deep and Permanent Violet Blueish. Use a barely damp ½-inch (13mm) flat to soften some of the edges. Use the same colors and brush to paint the rock formations on the left of the painting. Suggest the shadows and pile of fallen logs with very dark mixes of Primary Blue-Cyan, Brown Stil de Grain and Permanent Violet Blueish. Suggest negative shapes of debris and rocks using the same colors.

4 Develop the Shadows

Paint the trunk of the tree with a no. 8 round and dark and varied mixes of Permanent Violet Blueish, Orange Lake and Primary Blue-Cyan. Paint the leaves at the top of the tree with the same brush and dark mixes of Permanent Green Deep and Brown Stil de Grain. Using a mix of Brown Stil de Grain, Permanent Violet Blueish and Orange Lake, continue adding darks to the foreground logs and rocks. Add some darker values to the water using the round brush and a mix of Primary Blue-Cyan, Permanent Violet Blueish and Brown Stil de Grain.

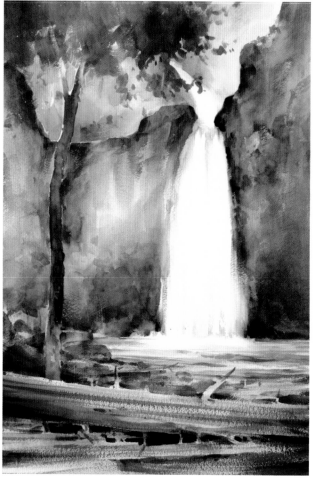

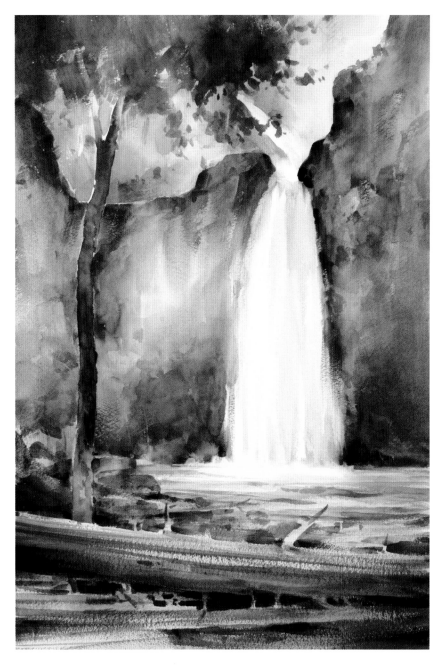

5 Add Color to Water and Foreground

Add some color and value to the falling water using a 1-inch (25mm) flat and a wet mix of Primary Blue-Cyan, Permanent Violet Blueish and Brown Stil de Grain. Use a damp 1-inch (25mm) bristle brush to soften some of the edges. Apply a glaze of Orange Lake and Permanent Violet Blueish to the logs toward the bottom of the shapes while keeping the tops of the logs relatively light.

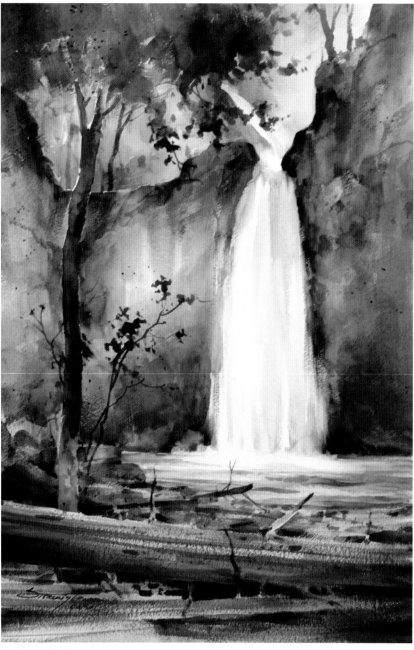

In the Columbia River Gorge
Watercolor on 300-lb. (640gsm) Fabriano Artistico paper
22" × 15" (56cm × 38cm) • Private collection

6 Establish Depth and Interest With Foreground Details

Paint additional leaves on the upper part of the trees and add some leaves on the lower parts with a no. 8 round brush and dark mixes of Permanent Violet Blueish, Permanent Green Deep and Brown Stil de Grain. Use a no. 6 rigger brush and dark mixes of Brown Stil de Grain and Permanent Violet Blueish to suggest smaller branches. Use the same colors to suggest a few branches on the logs in the foreground. A lighter mix of the color can be used with a no. 8 round brush to paint a few smaller trees at the top of the waterfall. Paint a light glaze of Golden Lake over the foreground logs and echo the color in two or three other small areas in the painting. Finally use a rigger brush and a dark mix of Permanent Green Deep and Brown Stil de Grain to splatter a few leaves in the trees and bushes.

Peaceful, Still Lake

Lakes with reflections are beautiful and serene, but can often require some special techniques to capture the glassy surface of the water with a shimmer of a reflection. Still water casts not only the colors above the water but also the shapes. It is an excellent opportunity to use a wet-on-wet technique for the reflections to give the shapes a softer blurred edge in comparison to the shapes being reflected.

MATERIALS LIST

PAPER
300-lb. (640gsm) cold-pressed watercolor paper

PAINTS
Avignon Orange
Brown Stil de Grain
Green Blue
Indian Yellow
Permanent Green Deep
Permanent Yellow Lemon
Primary Blue-Cyan

BRUSHES
½-, 1- and 2-inch (13mm, 25mm and 51mm) stiff bristles
½-, 1- and 2-inch (13mm, 25mm and 51mm) flats
no. 6 rigger
no. 8 round

OTHER
2B pencil
Kneaded eraser
Knife
Tissue

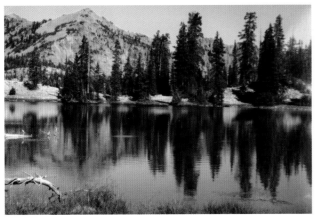

Reference Photo
This photograph, taken by Annie McMullen, shows a beautiful reflection of color and shapes that suggests a slight breeze because of the shimmer on the water. The trees on the shore are slightly lighter in value than the reflections. The angle of the waterline is tilted in the photograph, which is a common problem when taking pictures of anything that is generally level. To make the painting read properly, we will level the waterline.

Sketch the Simple Shapes
Make certain that the waterline is level and not directly in the center of the painting.

1 Paint the Water
Wet the area of paper from the waterline to the bottom of the paper thoroughly, wait a few minutes and wet it again. Tilt the paper and use a 2-inch (51mm) flat to apply a wet, rich wash of Primary Blue-Cyan starting at the waterline and working down to the bottom of the painting. While the paper is still wet, use a 1-inch (25mm) flat and a dry mix of Avignon Orange and Indian Yellow to suggest some of the color of the background hills at the top of the reflection. Use the same brush to apply dry and varied mixes of Permanent Green Deep, Brown Stil de Grain and Green Blue to suggest the reflections of the trees. Start at the waterline and pull down with the brush being certain to vary the colors and sizes of the trees. Use a 2-inch (51mm) bristle brush to apply a heavy application of Indian Yellow, Brown Stil de Grain and Primary Blue-Cyan at the bottom of the painting to suggest grass in the foreground. When the paper has lost its shine, use a damp ½-inch (13mm) flat to lift a few suggestions of shimmer across the reflections. Painting the reflections first before you paint the objects that are casting the reflections allows you to be more expressive with your brushstrokes and gets the reflections in place quickly while the paper is wet. Let dry.

2 Paint the Background and Sky
Wet the paper from the waterline to the top of the paper and use a 2-inch (51mm) flat and a wet mix of Primary Blue-Cyan to paint the sky. With the paper only slightly tilted toward you, start at the top and apply the color as a graded wash, getting lighter as you approach the waterline. While the sky is still wet, use a 1-inch (25mm) flat and a dry mix of Avignon Orange and Indian Yellow to paint the distant hills. Vary some of the colors as you paint the hills to add interest to the shapes. While the shapes of the hills are still wet, use a no. 8 round brush and a dark, dry mix of Primary Blue-Cyan and Brown Stil de Grain to paint the distant trees. Leave some white, unpainted paper at the bottom of the hills and along the waterline in a few spots. Use a ½-inch (13mm) flat and a mix of Indian Yellow and Primary Blue-Cyan to paint the area of grass along the waterline on the right side of the painting. Let dry.

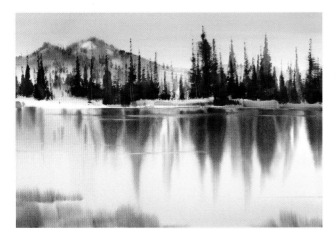

3 Develop the Middle Ground

Paint the large trees along the shoreline with a 2-inch (51mm) bristle brush and heavy mixes of Brown Stil de Grain, Green Blue and Indian Yellow. Vary the heights of the trees and keep the shapes relatively in line with the reflections below the shapes. As the trees begin to lose their shine use a beveled brush handle or knife to scrape a few tree trunks into the shapes. Use a damp ½-inch (13mm) bristle brush to lift small highlights on the distant ridges.

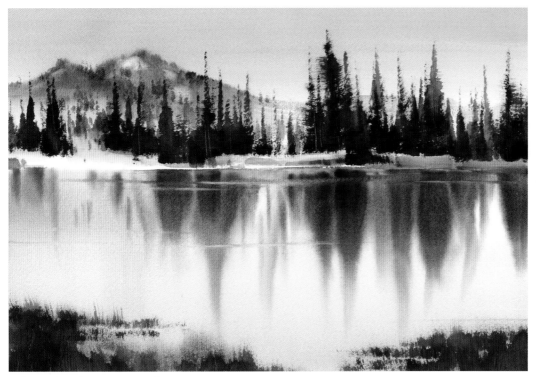

4 Develop the Foreground

Paint the foreground grass with a 2-inch (51mm) bristle brush and a dark mix of Brown Stil de Grain, Indian Yellow and Permanent Green Deep. Use the same colors and brush to suggest some reflections of the grass.

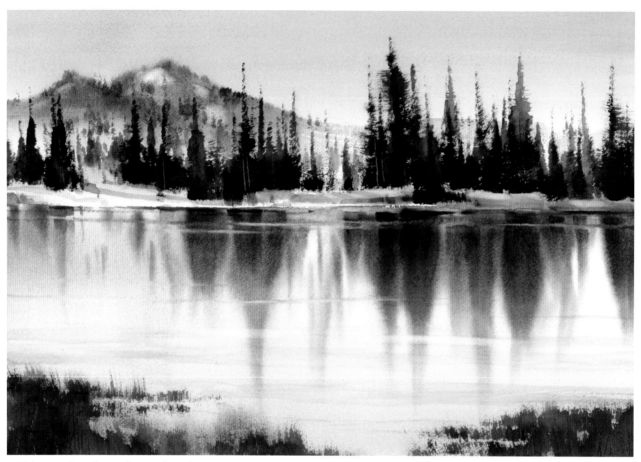

5 Strengthen the Lights and Darks

Use a ½-inch (13mm) flat and a wet mix of Avignon Orange and Brown Stil de Grain to suggest a few cast shadows on the shoreline. Use a damp ½-inch (13mm) bristle brush to loosen and blot some of the grass on the right side of the shoreline. When dry, glaze a wet wash of Permanent Yellow Lemon to suggest sunlight hitting the grass. Use a ½-inch (13mm) flat and dark mixes of Brown Stil de Grain and Green Blue to strengthen the reflections at the base of the shoreline. Soften some of the edges with a damp ½-inch (13mm) flat. Use the same brush and a wet mix of Primary Blue-Cyan to paint a few streaks across the water in the foreground. Soften some of the edges with a damp 1-inch (25mm) bristle brush. Use the same damp brush to scrub and blot a few more suggestions of shimmer on the water.

Step Four: Add Detail and Refine

Add More Trees
Use the no. 8 round and a medium-dark mix of Brown Stil de Grain and Green Blue to add a few more trees to the distant hills. Paint the trunks of the trees with a no. 6 rigger and Brown Stil de Grain.

Paint the Reeds
Use a rigger and a medium-dark mix of Brown Stil de Grain and Indian Yellow to paint the reeds next to the water. Adding some Green Blue to the mix to darken the colors, use a rigger to add a few dark suggestions in the grass.

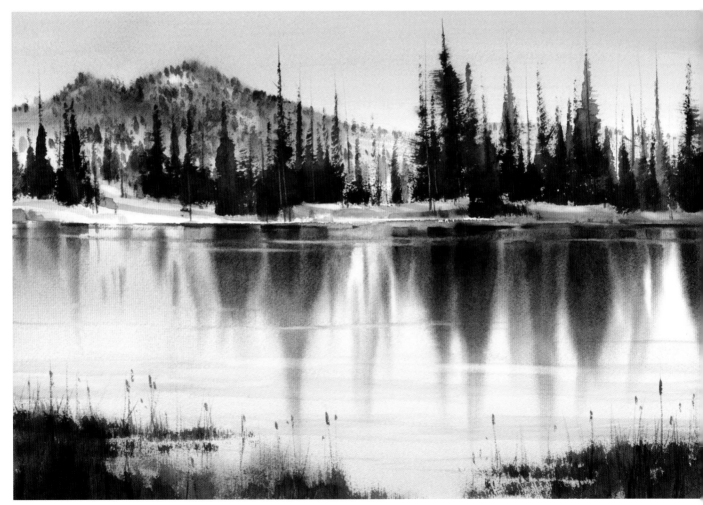

6 Add the Finishing Details
Finish the painting with a no. 8 round brush and a dark mix of Brown Stil de Grain and Green Blue to suggest a few more trees on the distant hills.

High Vintas Lake
Watercolor on 300-lb. (640gsm) Fabriano Artistico paper
15" × 22" (38cm × 56cm) • Private collection

Foggy River

The atmospheric conditions that are present in a foggy landscape suggest a wet and sometimes cold location depending on the colors that we use. Fog can sometimes be presented as a warm, damp atmosphere if we incorporate a little bit of warm color in the initial washes. Let the mood you are trying to suggest and the reference material guide your decision as to the warm or cold conditions.

MATERIALS LIST

PAPER
300-lb. (640gsm) cold-pressed watercolor paper

PAINTS
Brown Stil de Grain
Golden Lake
Orange Lake
Permanent Violet Blueish
Primary Blue-Cyan

BRUSHES
1-inch (25mm) stiff bristle
1- and 2-inch (25mm and 51mm) flats
no. 6 rigger
no. 8 round

OTHER
2B pencil
Credit card
Kneaded eraser
Tissue

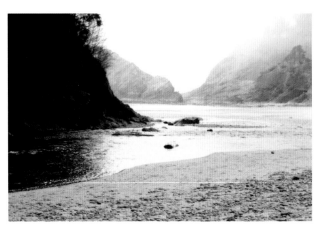

Reference Photo
This is just one of dozens of small rivers that run from the mainland onto the beaches and eventually to the ocean. I was particularly inspired by the wonderful shapes and foggy atmosphere at this location. The photograph is relatively colorless; however, and the rock in the center of the photograph does not lend itself to a good composition. To improve the composition we will move the rock higher and more to the right. While we're at it, let's add a little more color and richer values.

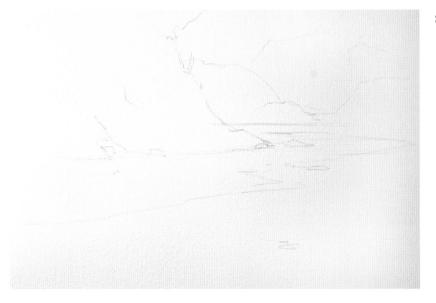

Sketch the Simple Shapes

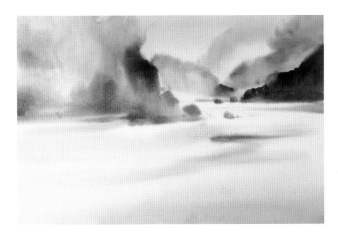

1 **Paint the Sky and Land Shapes**
Tilt the paper slightly toward you, wet the entire piece of paper, wait a few moments and wet the paper again. Working quickly before the paper dries, use a 2-inch (51mm) flat and a wet mix of Golden Lake, Permanent Violet Blueish, and Primary Blue-Cyan to paint the sky and area that will be water. Paint the suggestions of distant rock formations in the fog with a 1-inch (25mm) flat and a semidry mix of Brown Stil de Grain, Permanent Violet Blueish and Primary Blue-Cyan. Use a damp 1-inch (25mm) bristle brush to blend some of the edges as you paint, leaving areas of unpainted paper with soft edges to suggest fog. As you move closer into the distant shapes, use darker values of the same colors. Suggest the larger rock formation on the left with a 1-inch (25mm) flat and a mix of Orange Lake, Permanent Violet Blueish and Brown Stil de Grain. Let dry.

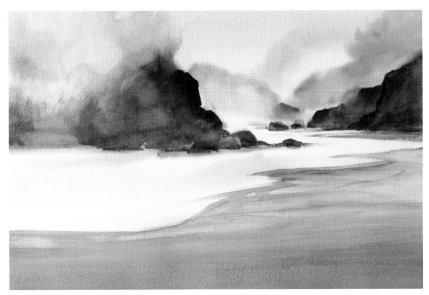

2 **Develop the Shapes**
On dry paper continue blocking in the shapes of the rocks and beach with a 1-inch (25mm) flat and darker midvalues of Orange Lake, Primary Blue-Cyan, Brown Stil de Grain and Permanent Violet Blueish. Use a 1-inch (25mm) damp bristle brush to blend and soften some of the edges. Using a 1-inch (25mm) flat brush and a no. 8 round brush, continue defining the shapes of the distant rocks using varied combinations of Orange Lake, Permanent Violet Blueish and Primary Blue-Cyan.

Step Two: Add the Darkest Values

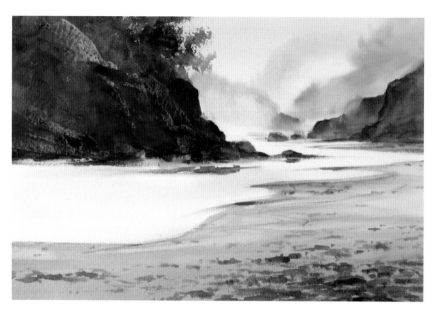

3 Establish Light and Shadow Areas

Paint the rocks on the left with a 1-inch (25mm) flat and varied dark mixes of Orange Lake, Primary Blue-Cyan, Permanent Violet Blueish and Golden Lake. Toward the top of the rocks suggest bushes with a 1-inch (25mm) flat and dark mixes of Primary Blue-Cyan and Golden Lake. To achieve the leafy appearance on the bushes, hold the brush level with the surface of the paper and use the side of the brush to scumble the shapes. When the paint on the rocks has lost its shine, use a credit card to scrape the highlights on the rocks. Use a no. 8 round and wet mixes of Permanent Violet Blueish, Brown Stil de Grain and Primary Blue-Cyan to paint the foreground rocks on the beach.

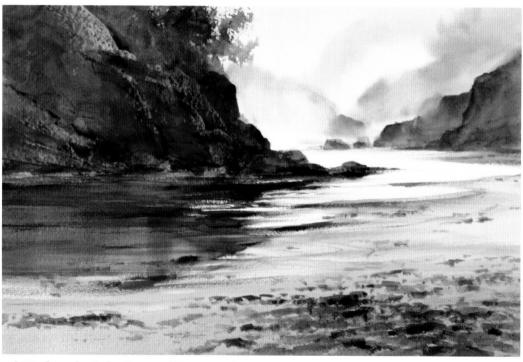

4 Work on the Reflections and Foreground

Paint the dark reflections using a 1-inch (25mm) flat and the same colors that were used to paint the rocks. Vary the colors and leave some areas of white paper to suggest a slight movement in the water. Use the same colors and a no. 8 round to add more colors to the foreground rocks on the beach. Use a no. 6 rigger and the dark mix of Primary Blue-Cyan and Permanent Violet Blueish to suggest a few dark accents on the large rock formation. Use a damp 1-inch (25mm) bristle brush to soften some of the edges.

Step Three: Selective Glazing

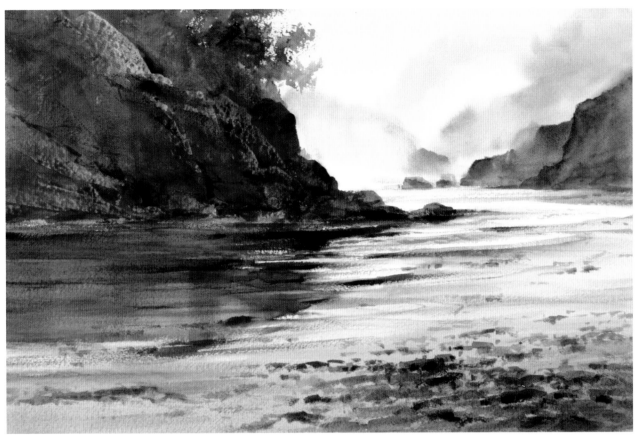

5 Darken a Few Areas Here and There

This painting requires very little glazing because much of the white paper is suggesting water with a reflection of the light sky. Add a little bit of light grayish blue made up of Primary Blue-Cyan, Brown Stil de Grain and Permanant Violet Blueish to the water areas using a no. 8 round brush. Be careful to leave areas of white paper that suggest shimmer on the water. Use a 1-inch (25mm) flat and a light mix of Permanent Violet Blueish, Brown Stil de Grain and Primary Blue-Cyan to darken some of the foreground beach and rocks.

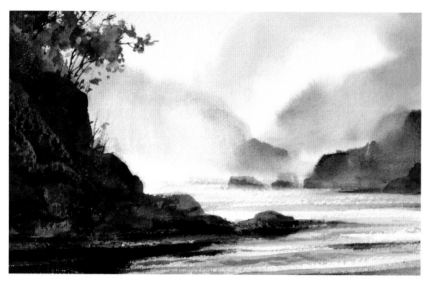

6 Strengthen the Fog and Water

Use a damp 1-inch (25mm) bristle brush to scrub and blot some of the color from the distant rocks to suggest layers of fog hovering over the ground. Enhance the reflections using a rigger and dark mixes of Permanent Violet Blueish and Brown Stil de Grain to suggest a little movement. Let these areas dry, then use the rigger to apply small ripples of movement in the reflections by applying clean water, waiting a few seconds, and then blotting and wiping hard and vigorously.

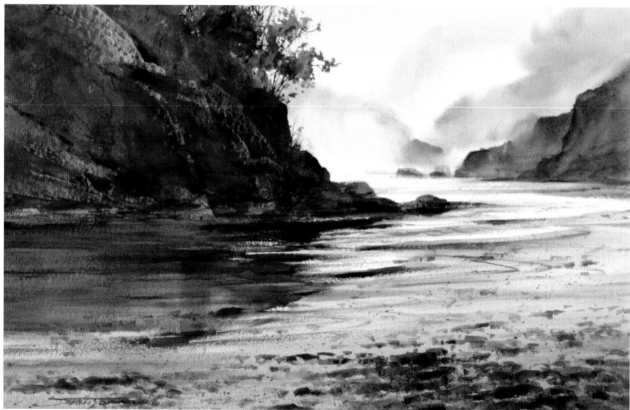

7 Strengthen the Depth of the Scene With Foliage and Foreground Details

Use a rigger brush and a dark mix of Golden Lake, Primary Blue-Cyan and Permanent Violet Blueish to add more leafy clusters to the edges of the existing bushes on top of the rocks. Use the same brush and a dark mix of Permanent Violet Blueish and Orange Lake to paint the small branches on the bushes. Use the same dark colors that you used for the rocks and a no. 8 round brush to paint the foreground rocks that are lying on the beach. Then add some splatter to the beach with a wet mix of Permanent Violet Blueish and Brown Stil de Grain. Be sure to cover the sky and water before splattering.

Meandering
Watercolor on 300-lb. (640gsm) Fabriano Artistico paper
15" × 22" (38cm × 56cm) • Private collection

Sunset

The photograph below was an inspiration for me to paint a sunset over a field of snow. Before we start on the actual painting, take a few minutes to familiarize yourself with the colors that we will be using. The vibrant sunset colors in this scene have a tendency to get muddy, so we'll explore using *buffer colors* to keep color vibrant and avoid mud.

MATERIALS LIST

PAPER
300-lb. (640gsm) cold-pressed watercolor paper

PAINTS
Brown Stil de Grain
Indian Yellow
Orange Lake
Payne's Grey
Permanent Violet Blueish
Primary Blue-Cyan
Primary Red-Magenta

BRUSHES
1- and 2-inch (25mm and 51mm) stiff bristles
½-, 1- and 2-inch (13mm, 25mm and 51mm) flats
no. 6 rigger

OTHER
2B pencil
Kneaded eraser
Knife
Tissue

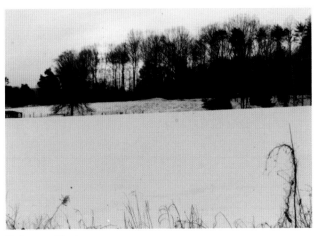

Reference Photo
The photograph does not have as much color in the sky as we want for this vivid sunset painting, so we'll add more color to paint our sunset.

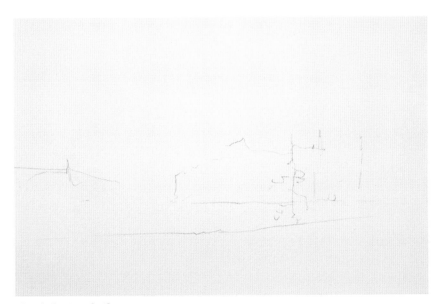

Sketch the Simple Shapes

What Are Buffer Colors?

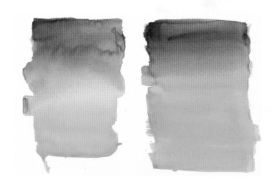

A buffer color is a color that works equally well with two complementary colors. When the two complementary colors are mixed together, they gray each other down and can easily become muddy if additional colors are added.

The buffer color keeps the two separated enough that you don't get mud and each color maintains its own identity.

In this demonstration we are using Indian Yellow and Permanent Violet Blueish in the sky. This is a recipe for mud if you don't find a way to separate the two colors. Primary Red-Magenta mixes beautifully with Indian Yellow to become a clean pinkish-orange color. It also mixes well with Permanent Violet Blueish, becoming a crimson color.

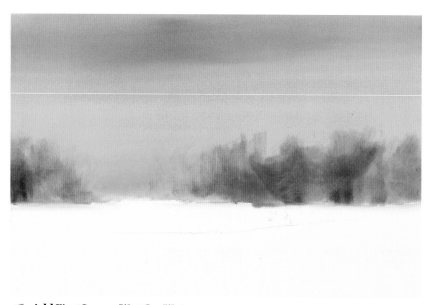

1 Add First Layers Wet-On-Wet

Begin by tilting the paper slightly toward you and wet the paper thoroughly from the horizon line to the top of the paper. With a 2-inch (51mm) flat add a wet mix of Indian Yellow along the horizon using horizontal strokes moving upward into the sky. Next introduce a wet mix of Primary Red-Magenta. Using horizontal strokes, bring some of the Primary Red-Magenta down into the Indian Yellow. Follow this with a wet wash of Permanent Violet Blueish starting at the top and moving down into the Primary Red-Magenta. Each time you introduce a color, you are wetting the paper, so keep working the colors until they blend softly.

Before the paper dries, use a 1-inch (25mm) bristle brush and Orange Lake to suggest a few trees on the horizon in front of the sun. As the trees get farther away from the sun, begin adding some Brown Stil de Grain and Payne's Grey to make the shapes darker toward the edges. Use a damp brush to soften the bottom edge of the trees. Let dry.

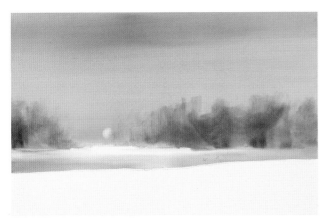

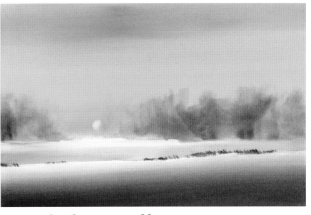

2 Create the Snow Shape

Use a 1-inch (25mm) soft flat and a wet mix of Primary Blue-Cyan and Payne's Grey to suggest a dip in the snow. The top edge of the shape should be softly blended using a 1-inch (25mm) flat and a barely damp bristle brush. Use a slightly damp bristle brush to scrub away some color suggesting the sun. As you lift the color, blot it with a piece of tissue.

3 Develop the Snowy Field

Thoroughly wet the bottom of the paper up to the lower edge of the existing blue shape with a 2-inch (51mm) bristle brush. While the area is wet, start at the bottom of the paper and lay a semi-wet mix of Primary Blue-Cyan and Payne's Grey. As you move near the top of the shape, use less paint and a slightly damp bristle brush to soften the top edge. It may be necessary to repeat the color application two or three times to get it dark enough. Always begin at the bottom and blend upward. If the color seems weak, add more each time with less water in the paint.

Before the paper dries, use the 1-inch (25mm) bristle brush and a dry mix of Orange Lake, Brown Stil de Grain and Payne's Grey to suggest a few clumps of grass on the ridgetop.

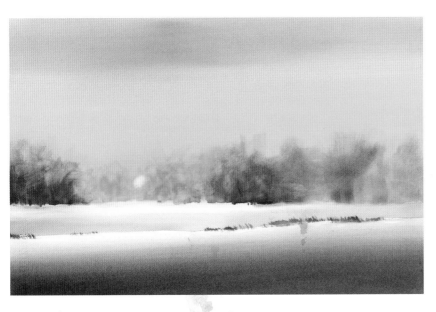

4 Develop Tree Shapes

Use a ½-inch (13mm) flat and Indian Yellow to suggest a few tree shapes in front of the sun. As you move farther away from the sun, begin adding some Brown Stil de Grain and Orange Lake. Use a damp 1-inch (25mm) bristle brush to gently soften some of the edges. Notice how the snow is beginning to look whiter with the darker addition of paint.

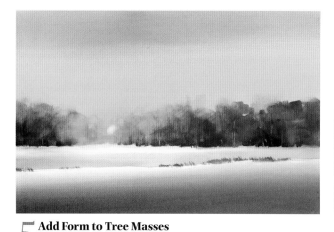

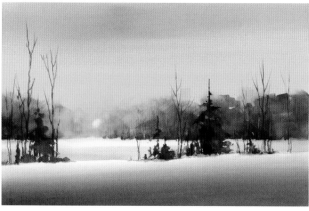

5 Add Form to Tree Masses

Starting at the edges of the painting use a 1-inch (25mm) bristle brush to paint a dark mix of Permanent Violet Blueish, Orange Lake and Brown Stil de Grain in the trees, alternating colors as you go for variety. As you move closer to the sun, begin adding more Orange Lake to the mix to suggest a glow on the trees. Suggest a few tree trunks on the bottom edge of the shapes. Use a damp 1-inch (25mm) bristle brush to soften some of the treetops. Before the trees dry and just when they have lost their shine, use a knife to scrape in a few individual tree trunks. Be careful that you put in only a few.

6 Add Middle Ground Trees

Use a dark, wet mix of Orange Lake and Payne's Grey with a 1-inch (25mm) flat soft brush to paint the pine trees in the middle ground, taking them above the distant trees to create depth in the painting. Use a no. 6 rigger brush and the same colors to suggest the small branches and tall, upright trees. As the shapes get close to the sun, add more Orange Lake to the color mixes. While the paint is still wet, the tall, upright tree on the left nearest the sun should be painted with Orange Lake, adding a few dark accents with some of the darker colors you have mixed. At this stage of the painting do not get into too much detail with the trees. Merely suggest their location and shapes.

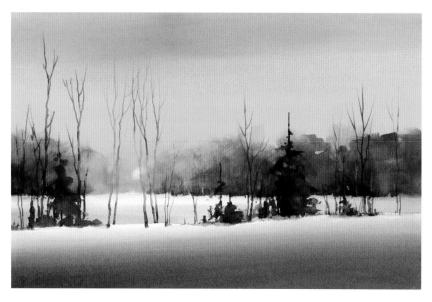

7 Develop Middle Ground

Use a rigger and Orange Lake to paint the trees directly in front of the sun. The shapes should get darker toward the tops and bottoms. Use the rigger brush with clean water to blend the orange and darker shapes together. When you paint the tree shapes that cross directly over the sun, use a tissue to blot some of the color.

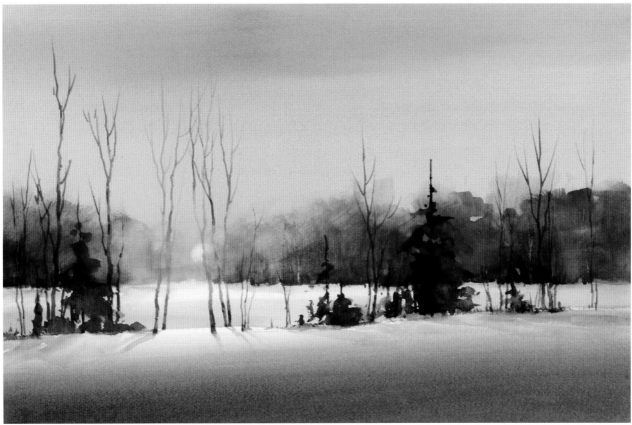

8 Add Shadow Shapes

Use a ½-inch (13mm) flat and a wet mix of Primary Blue-Cyan and Permanent Violet Blueish to paint some cast shadows on the top of the ridge. Use a damp ½-inch (13mm) flat to softly blend the shadows into the blue background. Remember that cast shadows follow the contour of the terrain, so give them a slight curve to suggest that the ground slopes downward. Use a lighter mix of the same color to suggest a few shadows on the snow at the base of the trees near the sun.

Step Four: Add Detail and Refine

9 Refine the Trees
Use a 1-inch (25mm) flat and a wet mix of Orange Lake, Permanent Violet Blueish and Brown Stil de Grain to suggest a crown of branches and leaves on the top of the trees. Use a clean, damp 1-inch (25mm) bristle brush to soften some of the edges. Vary the colors a little, getting more orange as you approach the sun. Let dry.

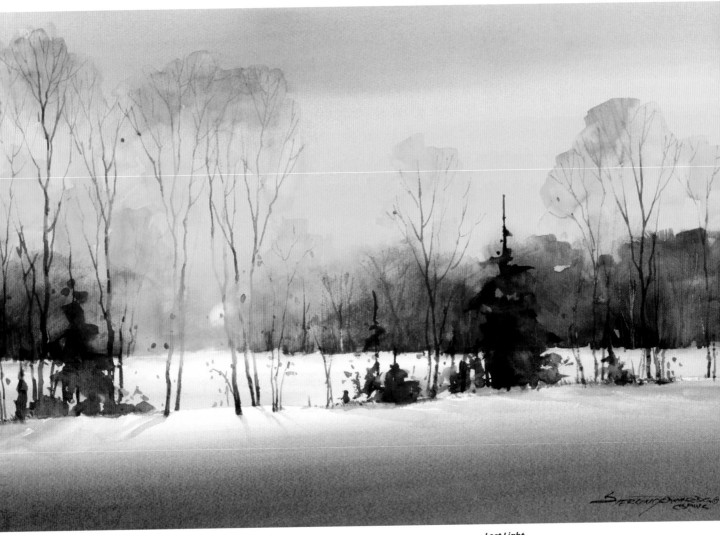

10 Finish the Painting
Use a rigger to suggest some of the finer details of the trees by including the smaller branches with a mix of Orange Lake and Payne's Grey. Stop the tiny branches at the crest of the trees. Go back into the trunks of the closer trees and add a little more dark to give the area more contrast. Use the rigger and a mix of Orange Lake and Brown Stil de Grain to suggest a few random leaves.

Last Light
Watercolor on 300-lb. (640gsm) cold-pressed Fabriano paper
15" × 22" (38cm × 56cm) • Private collection

Autumn Trees

Autumn scenes are always popular subjects to paint as they allow us an opportunity to get really crazy with color. Birch trees also a popular subject with watercolor artists because their semiwhite trunks make for strong, negative shapes. When you combine the autumn colors with the white negative shapes of birch trees, you have a recipe perfectly suited for transparent watercolors.

MATERIALS LIST

PAPER
300-lb. (640gsm) cold-pressed watercolor paper

PAINTS
Brown Stil de Grain
Golden Lake
Indian Yellow
Permanent Red Deep
Permanent Violet Blueish
Permanent Yellow Lemon
Primary Blue-Cyan
Primary Red-Magenta

BRUSHES
½-, 1- and 2-inch (13mm, 25mm and 51mm) flats
1-inch (25mm) stiff bristle
no. 6 rigger

OTHER
2B pencil
Kneaded eraser
Tissue

Reference Photo
The October colors in these woods were extraordinarily brilliant. There is more green in this photograph than I wish to paint, so I will substitute more of the bright oranges and yellows for the green. I think it will also be a good idea to add more of the negative trees in the background woods to strengthen the composition.

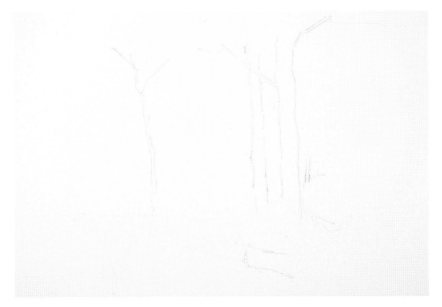

Sketch the Simple Shapes
Since this painting will focus mainly on the clusters of color, there is no need to get too detailed with the drawing. To make the composition more balanced move the small single tree farther to the left than is seen in the photograph.

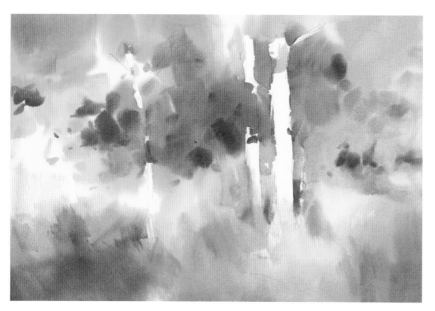

1 Lay a Base of Color Shapes

Tilt the paper slightly toward you and use a 2-inch (51mm) flat and a very light, wet mix of Permanent Yellow Lemon to wet the entire paper except for the shapes of the three main trees, which you will want to paint around. While the paper is still wet, use heavier and varied mixes of Permanent Yellow Lemon, Indian Yellow, Primary Red-Magenta and Permanent Red Deep to suggest the autumn foliage. As you apply the colors, use thicker and heavier mixes to suggest individual clusters of leaves. Use the same brush and a mix of Brown Stil de Grain and Indian Yellow to suggest the grass beneath the trees. Let dry.

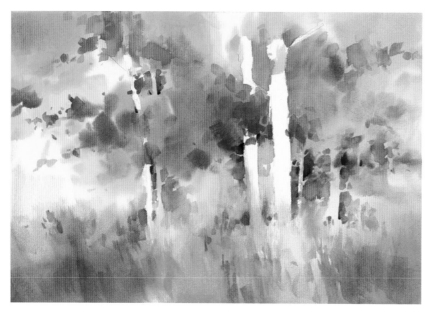

2 Refine and Add Foreground Shapes

Continue using a 1-inch (25mm) flat and varied mixes of Indian Yellow, Permanent Red Deep and Primary Blue-Cyan to suggest more trees in the woods that will be negative shapes. Soften some of the edges with a damp 1-inch (25mm) bristle brush. Vary the space between the trees and vary the sizes of the trees to make the painting more interesting. Use the same brush and colors to paint more detail in the leaves. Use a 1-inch (25mm) flat and mixes of Golden Lake, Indian Yellow and Primary Blue-Cyan to suggest the grass. Use a damp 1-inch (25mm) bristle to soften some of the edges.

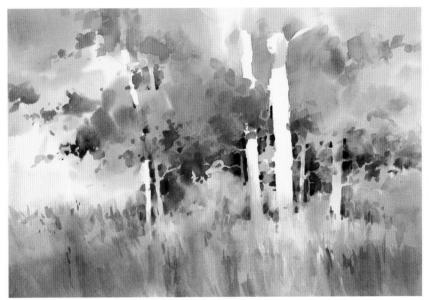

3 Add Depth With Background Trees

Add darker values in the background negative trees using a ½-inch (13mm) flat and dark mixes of Permanent Violet Blueish, Permanent Red Deep and Primary Blue-Cyan. Use the same brush and colors to darken some of the leafy clusters. Soften an occasional edge with a damp bristle brush. Begin suggesting a little more detail in the grass using darker mixes of Golden Lake, Permanent Violet Blueish and Primary Blue-Cyan.

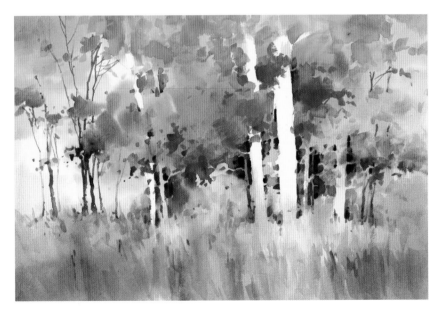

4 Develop the Background

Use a no. 6 rigger and dark mixes of Golden Lake, Permanent Violet Blueish and Permanent Red Deep to paint the small positive trees. Continue adding dark mixes of Permanent Red Deep and Permanent Violet Blueish to some of the leafy shapes using a ½-inch (13mm) flat.

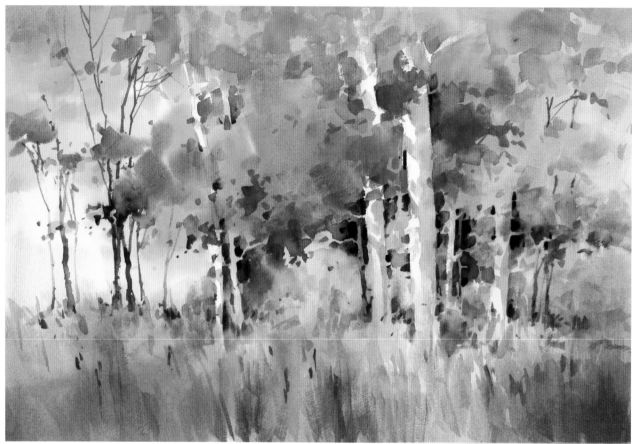

5 Develop Light and Shadow

Add color and suggested shadows on the white trunks of the trees with a ½-inch (13mm) flat brush and a light mix of Permanent Violet Blueish, Golden Lake and Primary Blue-Cyan. Leave some white to suggest filtered sunlight hitting the trees. Darken the grass toward the bottom of the painting with a 1-inch (25mm) flat and a mix of Golden Lake and Permanent Violet Blueish. The last step of the glazing process is using a 1-inch (25mm) flat brush to add thin washes of Permanent Yellow Lemon to some of the areas of foliage toward the top of the painting to suggest sunlight hitting the higher reaches of the trees.

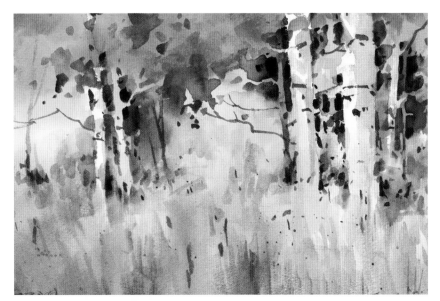

6 Strengthen the Illusion of Depth With Texture Details

Use a rigger and a dark mix of Permanent Violet Blueish, Primary Blue-Cyan and Indian Yellow to paint some of the small branches and to add a few more negative shapes in the area of the largest trees. Use the same brush and color mix to splatter some texture on the ground to suggest weeds. The bark textures of the trees can also be painted with the rigger brush and the same dark color. Use the rigger and a dark mix of Permanent Red Deep and Permanent Violet Blueish to paint a few individual leaves on the bottom of the trees.

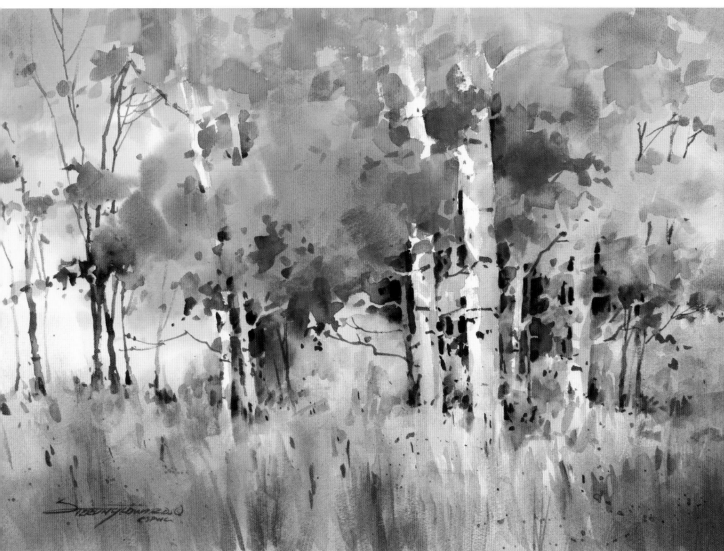

An Autumn Walk
Watercolor on 300-lb. (640gsm) Fabriano Artistico paper
15" × 22" (38cm × 56cm) • Private collection

Marsh

I love marshes. Aside from the water and the beautiful reflections, the colors are often beautiful especially in October. The earth tones usually found in the marsh are accentuated with gorgeous autumn colors.

MATERIALS LIST

PAPER
300-lb. (640gsm) cold-pressed watercolor paper

PAINTS
Avignon Orange
Brown Stil de Grain
Golden Lake
Green Blue
Orange Lake
Permanent Violet Blueish
Primary Red-Magenta

BRUSHES
1-inch (25mm) stiff bristle
½-, 1- and 2-inch (13mm, 25mm and 51mm) flats
no. 6 rigger

OTHER
2B pencil
Kneaded eraser
Knife
Tissue

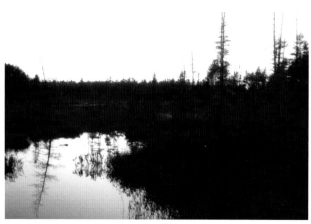

Reference Photo
This photograph was taken one evening when things were getting pretty dark. I chose to paint this scene using this photograph as a reference because it has some beautiful shapes and does not dictate to me what colors to use. I know from having been there that there is a wide variety of earthy yellows, browns and greens as well as autumn oranges and reds.

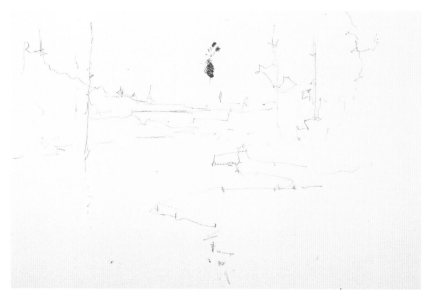

Sketch the Simple Shapes

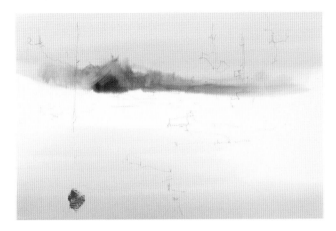

1 Add First Layers Wet-On-Wet
Wet the entire surface with a 2-inch (51mm) flat brush. Working quickly before the paper dries, start just above the horizon and lay a wet wash of Golden Lake working from the horizon upward into the sky.

With the same wet wash of color start at the bottom of the painting and lay a wash, again moving upward to the horizon. Keep the area near the center of the painting white.

Next lay a wet wash of Permanent Violet Blueish, starting at the top of the paper and moving down into the Golden Lake. Repeat the process at the bottom of the paper by applying the Permanent Violet Blueish and moving upward into the Golden Lake.

While the sky is still wet, use a dry mix of Avignon Orange and Green Blue to suggest a few distant tree shapes above the horizon. Use a damp 1-inch (25mm) bristle brush to soften some of the edges. Let dry.

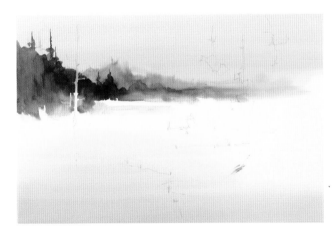

2 Develop Background Tree Shapes
Use wet mixes of Golden Lake, Green Blue and Brown Stil de Grain to paint some of the distant trees. Use a 1-inch (25mm) flat to paint the larger tree masses with an assortment of the mixed colors. The top edge needs to suggest tree tops of varying heights. While painting the tree masses, use negative painting techniques to paint around some of the dead trees. Use a 1-inch (25mm) damp bristle brush to softly blend the bottom edge of the tree masses. The small white area to the right of the trees will be a distant pond of water, so keep this area level and white.

Close-Up of Negative Tree Shapes

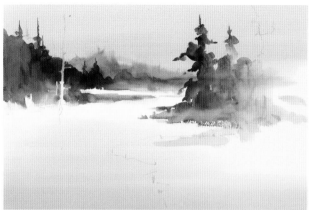

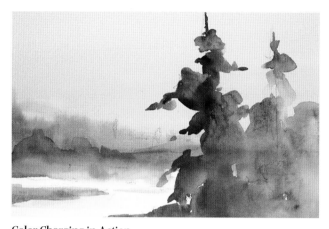

3 Develop Middle Ground Tree Shapes

Use wet, rich mixes of Orange Lake, Golden Lake, Brown Stil de Grain and Green Blue to charge color into the foliage on the trees to the right of the water with a ½-inch (13mm) flat. Pay particular attention to the outside edges of the shapes to make them irregular, gently softening some of the edges. Use a 1-inch (25mm) barely damp bristle brush to soften the right and bottom edges. Use a ½-inch (13mm) flat and a mix of Golden Lake and Green Blue to suggest the distant shoreline to the left of the trees.

Color Charging in Action

This is an excellent example of the power of charging colors. While the shapes are wet, drop in additional colors and allow them to mix on their own on the paper.

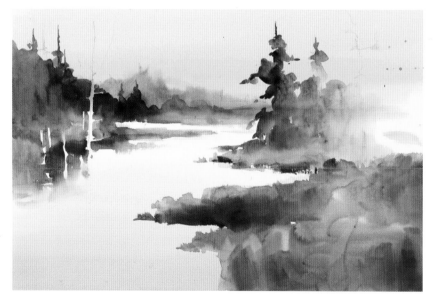

4 Develop Foreground Shapes

With a 1-inch (25mm) flat, lay wet washes of Golden Lake, Brown Stil de Grain and Primary Red-Magenta in the grassy areas. As you paint the grass, vary the colors to give the grass some form. Apply darker colors at the base of the grass where it comes in contact with the water. Use a damp 1-inch (25mm) bristle brush to soften some of the edges. Let dry.

Step Two: Add the Darkest Values

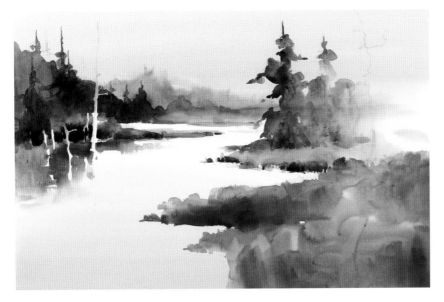

5 Add Form to Larger-Shaped Masses

Use a ½-inch (13mm) flat and a wet dark mix of Green Blue and Brown Stil de Grain to suggest a few more pine tree shapes on the left of the pond. Suggest a few more negative trees as you apply the darker color and use this opportunity to show the top of the grass. Use a barely damp ½-inch (13mm) soft flat brush to soften some of the edges at the base of the dark trees where they come in contact with the grass.

On the right side of the painting use a ½-inch (13mm) flat and a dark mix of Brown Stil de Grain and Green Blue to suggest a few dark areas at the base of the trees to show the top of the grass.

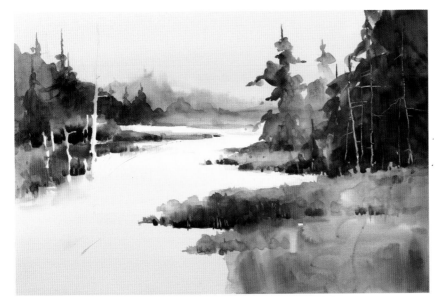

6 Continue Developing Shapes

Use a 1-inch (25mm) flat and very dark mixes of Orange Lake, Green Blue and Brown Stil de Grain to paint the large tree mass on the right. Vary the colors by charging as you paint the shapes. Do not try to make specific shapes within the large dark mass. It is the outside edge that will distinguish the shapes as trees, so suggest a few tree shapes on the edges.

Use a ½-inch (13mm) flat and a dark mix of Primary Red-Magenta, Green Blue and Brown Stil de Grain to paint the darker areas of grass toward the foreground. Repeat this on the grass shapes to the left. Use a damp ½-inch (13mm) flat to soften some of the edges. As the shapes begin to lose their shine, use a knife or similar tool to scrape a few tree trunks and grass shapes.

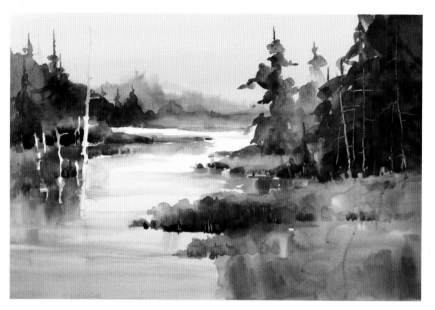

7 Start Painting the Water

Use a 1-inch (25mm) flat and wet mixes of Golden Lake, Green Blue and Brown Stil de Grain to indicate a few reflections of color in the water. Take each shape separately and use a damp 1-inch (25mm) bristle brush to soften many of the edges as you go. While the shapes are wet, pull a clean, damp ½-inch (13mm) flat across them to suggest a little bit of movement on the water. Wipe the brush with a tissue after each application.

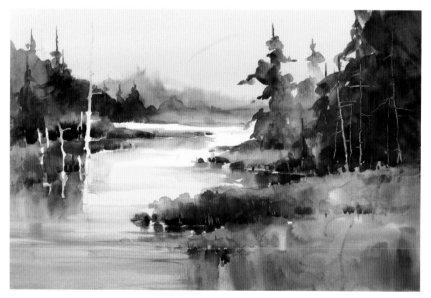

8 Continue Work on the Water

Use a ½-inch (13mm) flat and a wet mix of Primary Red-Magenta, Brown Stil de Grain and Golden Lake to pull some reflections down under the grass in the foreground. While the shapes are still wet, use a clean, barely damp ½-inch (13mm) flat to lift a few suggestions of movement on the water.

Step Four: Add Detail and Refine

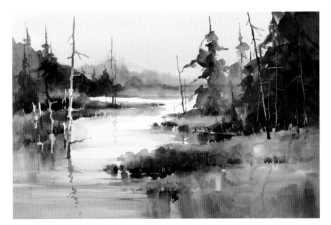

9 Refine the Trees

With a rigger and wet mixes of Avignon Orange, Brown Stil de Grain and Green Blue paint the dead trees in the swamp. In the trees that started as negative shapes, use a clean, damp brush to soften the edge where the positive shape and negative shape join together. Use the rigger and a light value to suggest a few more dead trees in the distance.

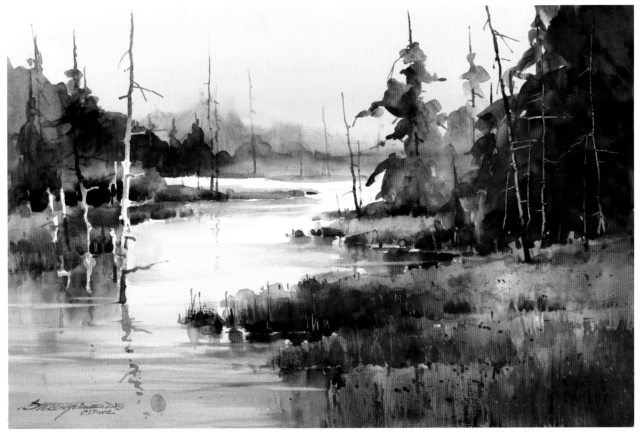

10 Finish the Painting

Use a 1-inch (25mm) flat and a heavy, wet mix of Brown Stil de Grain, Green Blue and Primary Red-Magenta to add more color and value to the foreground grass. When dry, use a rigger to add a few splatters of the dark reddish brown mix to suggest weeds and also to paint a few individual weeds at the edge of the grass next to the water. Be sure to cover the sky and areas you do not want to get splattered. Let dry. Then use the rigger to apply a few strokes of clean water in the grass shapes. Wait a few seconds and wipe the area hard and vigorously to lift some of the color, suggesting lighter-value weeds against a darker background.

Finally, use a clean, damp ½-inch (13mm) flat to loosen a few shimmers of light on the water. After lifting the color blot the area with a piece of tissue.

Somewhere in Algonquin
Watercolor on 300-lb. (640gsm) Fabriano Artistico paper
15" × 22" (38cm × 56cm) • Private collection

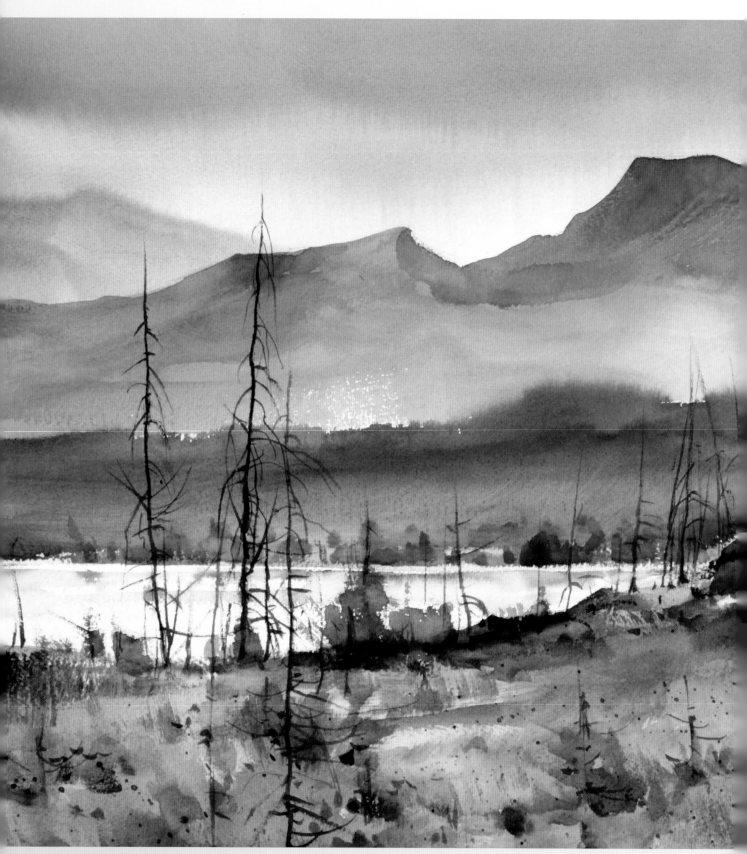

Morning on the Columbia
Watercolor on 300-lb. (640gsm) cold-pressed Arches paper
15" × 22" (38mm × 56mm) • Private collection

Conclusion

*I*would like to personally thank you for including this book in your collection of art-related material. Needless to say, this book covers only a small variety of subjects that can be painted using my four-step process. It does not matter if you paint from photographs in a studio as I do or paint in the field; it's just reassuring to have a workable plan. Those of you who wish to paint loose will find this particularly true as you structure your painting around the larger shapes using larger brushes while selectively saving the smaller detailed shapes for the end. There's no substitute for practice, however. I have found that spending a few hours practicing specific landscape elements such as various types of trees was as beneficial as attempting a complete painting. These little doodles as I call them were time well spent because they focused on a specific rather than multiple elements. The more I practiced, I began to build the confidence to include these elements into a larger painting. With practice comes confidence and with confidence comes competence. Each painting is a new adventure. Some will work and some won't. After all, watercolors do seem to have a mind of their own, and it's the occasional unpredictability of watercolor that makes it such a wonderful medium. I strongly encourage you to try the exercises in this book, attend classes and workshops, keep an open mind to new ideas and share ideas with other artists. But most of all, enjoy the journey.

Sterling Edwards

Index

Ideas. Instruction. Inspiration.

Luminous Watercolor with Sterling Edwards: The Wooded Landscape

ISBN 13: 978-1-4403-0701-0

Z7700 • DVD running time: 67 minutes

Luminous Watercolor with Sterling Edwards: The Evening Landscape

ISBN 13: 978-1-4403-0698-3

Z7697 • DVD running time: 69 minutes

ISBN-13: 978-1-60061-343-2

Z3228 • Hardcover • 144 pages

For artists working in watermedia, *Watercolor Artist* magazine is the definitive source for creative inspiration and technical information. Find the latest issue on newsstands, or order online at www.artistsnetwork.com/magazines.

Recieve a **FREE GIFT** when you sign up for our free newsletter at **www.artistsnetwork.com/newsletter_thanks**.

Splash: The Best of Watercolor

The *Splash* series showcases the finest watercolor paintings being created today. A new book in the series is published every other year by North Light Books (an imprint of F+W Media) and features nearly 140 paintings by a wide variety of artists from around the world, each with instructive information about how it was achieved — including inspiration, tips and techniques.

Gallery

Passionate Brushstrokes
Rachel Rubin Wolf

Splash 10 explores "passion" through the work and words of 100 contemporary painters. With each vividly reproduced modern-day masterpiece, insightful firsthand commentary taps into the psyche of the artist to explore where their passion comes ...

Watercolor Discoveries
Rachel Rubin Wolf

Splash 9 holds its own as a visual showcase, representing some of the best work being done in watercolor today. But of course, that's only the half of it. *Splash* is much more than a pretty face. In the same open, giving spirit that ha...

Want to see your art in print?

Visit **www.splashwatercolor.com** for up-to-date information on future North Light competitions or email us at *bestofnorthlight@fwmedia.com* and ask to be put on our mailing list!